IMAGES
of America

CLARKSDALE AND
COAHOMA COUNTY

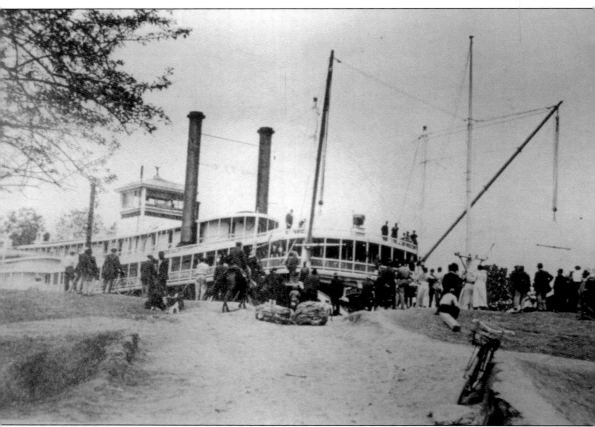

The Mississippi River has always been a looming presence in Coahoma County, threatening and controlling the lives of its inhabitants. A call of "Steamboat a-coming!" was a welcome sound to early settlers and cause for celebration. All usual activity would cease as everyone ran to the landing to witness the majesty of a massive, ornate boat gliding on the river toward them. At times, as if in fury, the river would cause the banks to cave as it gobbled up towns like Port Royal and Delta and sent them to its depths. Floods caused the destruction of crops, homes, and towns, and many businesses and farms suffered financial ruin. Settlers were not deterred, however, as they rebuilt over and over, showing their strength and determination. (Courtesy of M.M. Painter.)

ON THE COVER: The most effective way to control weeds and grasses in the fields was by chopping, one of the most labor-intensive practices on a farm. After the Civil War and migration, choppers were recruited in towns and brought to the farm as day labor. Children would go to the fields and play while the parents worked. (Courtesy of Library of Congress.)

IMAGES
of America

CLARKSDALE AND COAHOMA COUNTY

Judith Coleman Flowers
on behalf of the Carnegie Public Library

ARCADIA
PUBLISHING

Published by Arcadia Publishing
Charleston, South Carolina

Printed in the United States of America

Library of Congress Control Number: 2015949038

For all general information, please contact Arcadia Publishing:
Telephone 843-853-2070
Fax 843-853-0044
E-mail sales@arcadiapublishing.com
For customer service and orders:
Toll-Free 1-888-313-2665

Visit us on the Internet at www.arcadiapublishing.com

This publication is dedicated to Marie Harding Coleman Haynes, who had the foresight to believe in the future of Clarksdale, with its exceptional and lauded educational system that is second to none in the state.

CONTENTS

ACKNOWLEDGMENTS

The majority of the photographs in this publication were made available through the extensive collection archived in the Carnegie Public Library of Clarksdale and Coahoma County. This historical and genealogical information has been preserved in documents important to the building of the city and county and the people involved. The assistance of the library staff, including director Sarah Ruskey, Janice Williams, Claire Drew, and Tremell Derring, is greatly appreciated. I am especially grateful to JoAnn Blue, reference librarian, for helping me navigate the collections and for encouraging me through the research process. My special thanks to Russell S. Hall for sharing his experience and advice throughout the assembly of this book. Thanks to Margaret Jordan-Walker for sharing levee board material, and John Connaway, archaeologist with Mississippi Department of Archives and History, for information concerning early Native American history.

Images in this volume appear courtesy of the following sources, indicated by abbreviations: Library of Congress (LC), Clarksdale/Coahoma County Chamber of Commerce (CC), Jack Bobo (JB), Stovall family (SF), Holmes Petty (HP), M.M. Painter (MMP), Russell S. Hall (RH), Gertrude Anderson (GA), and Mrs. James S. Dickerson Jr. (JSD). Unless otherwise attributed, images appear courtesy of the Carnegie Public Library of Clarksdale and Coahoma County.

INTRODUCTION

Standing before the US House of Representatives on April 25, 1874, statesman L.Q.C. Lamar of Mississippi stated, "My countrymen! Know one another and you will love one another." With this volume on the history of Clarksdale and Coahoma County, may you, the reader, come to know our people through the hardships faced by early settlers, the African American labor force that carved this landscape we call home, and the progressive people that wanted to build a better life for everyone.

In ancient history, this area was lowlands ruled by the mighty Mississippi River. The main channel gradually shifted westward, leaving ridges of sandy loam and lowlands known as "buckshot." Even after this relocation of the river, the frequent flooding brought deposits downstream that so enriched the soil of the Delta that it is one of, if not the most, fertile area in the world. Coahoma County is located in the center of this alluvial empire. Throughout the history of the region, it was a fact that nowhere else in the world could the same high-grade, long-staple cotton be grown. Through the efforts of many and over a long period of time, a system of levees was completed that facilitated further settlement of the area.

Hernando De Soto is said to have followed an old Indian trail called "Charley's Trace" across the Southern states from Florida and discovered the Mississippi River at Sunflower Landing in 1541. There are theories that he set foot in what is now Clarksdale.

There is much evidence of the Choctaw Indians and their life in this county. Numerous mounds exist, and many more have been obliterated by plows and land forming. The area has an excellent archeological presence today, and the excavation of villages has revealed evidence of the Choctaw presence, including hunting items, domestic and agricultural tools, beads, pipes, and pottery. Coahoma County was established in 1836 from part of the territory ceded by the Choctaw Indians in the Treaty of Dancing Rabbit Creek, the third major land concession made to the US government. The word *Coahoma* in the Choctaw language means "red panther." This county, according to popular belief, was named for Princess Coahoma Sheriff, daughter of a Choctaw chief named Sheriff who lived on Mackey's Lake. The road from Clarksdale to Friars Point that passed the Native American village by the lake was always called Sheriff Ridge Road.

The county was formed at a time when land speculation was reaching a peak, and Mississippi land was being bought and sold on a large scale. There was a financial depression in 1837, and land in the county could be bought for 25¢ an acre. There were land patents available through the government; the first ones were issued for land along the river. In 1834, two land entries were recorded, one by Howell R. Hopson and another by David Connerly.

The first industry in the county was the cutting of timber, of which there was no shortage. It is said that any seed that falls onto this soil grows. It is the story of these dense forests and, later, the fight to control weeds and grasses. River traffic was busy, especially with the movement of logs; steamboats pulled logs to ports and took on wood for fuel. Land next to the river housed sawmill communities, where many families lived and worked. As land was being cleared, family

gardens sprang up beside the log houses; then, crops were grown on a small basis. With the ever-expanding open space and fertile soil, it was inevitable that the county would turn to vast plantings of cotton and corn. An agricultural economy supported the county, and those involved in the industry made decisions based largely on keeping their labor.

Manufacturing companies did come into the area in later years, supplying jobs for both men and women. Not many of those remain today, and unemployment is high. There is a constant effort to attract more manufacturing, build highways to facilitate manufacturer-to-market transportation, and train residents with skills for available jobs. The casinos and tourist industries have contributed greatly to the economy and provided much-needed jobs in the Delta. The casinos train workers, promote from within, and provide benefits. Employees there enjoy a starting wage above minimum wage. Even transportation by government-supported companies is provided.

In the beginning, there was little interest among citizens in promoting the blues. When Sid Graves established the Delta Blues Museum on January 31, 1979, he did not get much positive feedback from the public, and it operated on very little funding. About this time, there was a resurgence of interest in blues. Those supporting the preservation of Clarksdale's blues history included award-winning journalist and photographer Panny Mayfield; Jim O'Neal, who founded *Living Blues* magazine and the record label Rooster Blues in Chicago; and Walter Thompson, a local attorney. Skip Henderson, a friend of Sid Graves and owner of a vintage guitar business in New Jersey, purchased the Illinois Central passenger depot, saving it from demolition. Thanks to a grant for restoration, the depot was restored, and Blues Alley was formed. Members of the band ZZ Top, via a contact with Howard Stovall Jr., took an interest in the Delta Blues Museum. Through them, the museum gained national attention. They picked up a plank at the former cabin of Muddy Waters in Stovall and had an electric guitar built from it. It is used in the Muddy Waters exhibit at the museum and symbolizes contemporary music's indebtedness to the blues. The band also held benefit performances for the museum. The county renovated the historic Illinois Central freight depot as the museum's final home. The House of Blues meticulously dismantled Muddy Waters's cabin, which had been damaged by the elements and a tornado, and had it preserved. It was taken on tour and then returned to the Delta Blues Museum. It is housed in a new addition to the museum.

Clarksdale gained international attention as word spread about its blues legacy. Today, on a daily basis, tourists are found on the streets and in the hotels, restaurants, and shops. Venues related to the blues occupy once-vacant stores, and people have moved here to open those businesses. Thousands attend the Sunflower River Blues and Gospel Festival, the Juke Joint Festival, and many smaller events, all of which provide the area with a much-needed economic boost.

Clarksdale became the most important city in the North Delta in the early years. Progressive settlers developed the city into what was called the "Golden Buckle on the Cotton Belt." The men and women responsible for this development deserve to be remembered for their perseverance, unselfish devotion, and public service.

Clarksdale might again become a shining beacon of the Delta if everyone is willing to work as one city and see themselves as citizens striving for the common good. The building blocks are in front of us, not behind us. Do we stumble over them, or start building a community of which we can all be proud?

One

A NEW FRONTIER

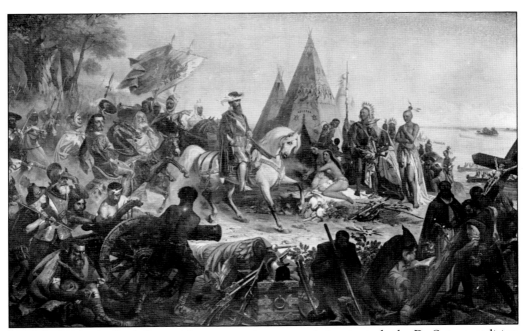

In 1935, Congress asked the president to appoint a commission to study the De Soto expedition and determine its true route through the Lower Mississippi Valley. The 400th anniversary of the event was approaching, and Congress wanted to know where the anniversary observances ought to be held. The United States De Soto Expedition Commission prepared a scholarly piece of work that proved, to the satisfaction of most historians, that De Soto had discovered and crossed the Mississippi River at a place later known as Sunflower Bend. (LC.)

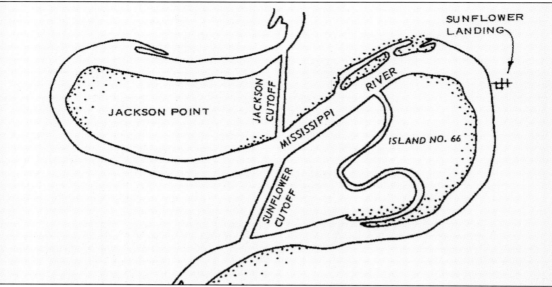

The Sunflower Cutoff was constructed in 1942 by the US Army Corps of Engineers. This cutoff removed a steamboat landing from the Mississippi River that had been known to rivermen since 1838. The resulting oxbow lake occupying the old bend was called De Soto Lake in honor of the discoverer of the Mississippi River. Sunflower Landing had been acknowledged as the "most likely" location of the discovery of the river in 1541 by Hernando De Soto. Here, after building flatboats, he and his 400 ragged troops crossed the river in darkness to avoid the Native Americans who constantly patrolled the river and with whom they had battled. With this crossing, the expedition entered what is now Arkansas. From Florida to the Mississippi River and beyond, De Soto and his men unsuccessfully sought gold and silver. (The Mississippi River Commission.)

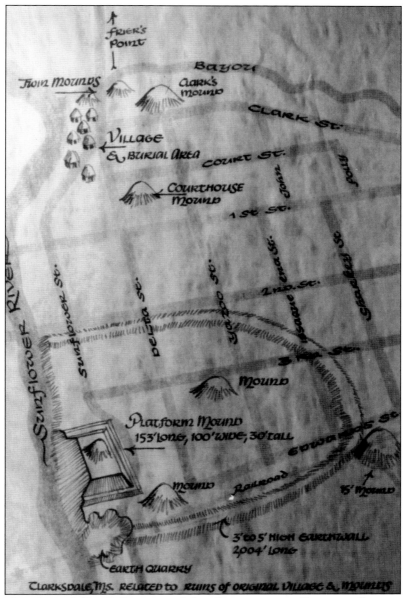

Harvard archaeologist Jeffrey P. Brain noted that Quizquiz was a Choctaw village on the site of what is now Clarksdale in 1541, when De Soto and his men passed through. They encountered the village of Quizquiz, which they took by assault, as reported in their chronicles. This map shows the locations of the village and mounds of Quizquiz, superimposed on a current grid of the streets of downtown Clarksdale. Artifacts point to the conclusion that De Soto and his men arrived in this area. Among the found pieces are "Clarksdale bells," sheet brass bells of Spanish origin. In time, the Quizquiz ceased to exist. It is believed that their numbers diminished and they moved downstream. The Choctaws were the main inhabitants of Coahoma County, numbering around 20,000 in the state. Since the late 1800s, mounds in the county have been investigated, revealing information about many inhabitants and clues to their everyday lives, from as early as 2000 B.C. (W.L. Holcomb Collection, drawing by Fred Beasley.)

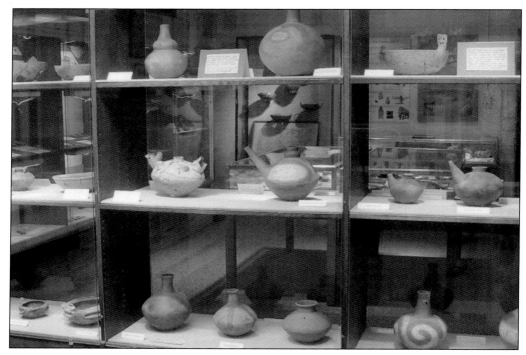

Pottery and artifacts found in the county date to the Late Archaic (Poverty Point) period, which stretched from 2000 to 500 B.C. Most of the Delta is covered by deep deposits of river silt, so generally the earliest material found is Late Archaic. A few older land surfaces in the Delta, along the edge of the bluffs and south between Cleveland and Greenville, still have material dating to the Paleo-Indian period (15,000–8,000 B.C.). Unfortunately, much of that area has been leveled, so many of the old sites are gone. Exhibits in the Carnegie Public Library include pottery from the Humber site, artifacts from the Carson Mounds, and collections from the Mississippi Department of Archives and History.

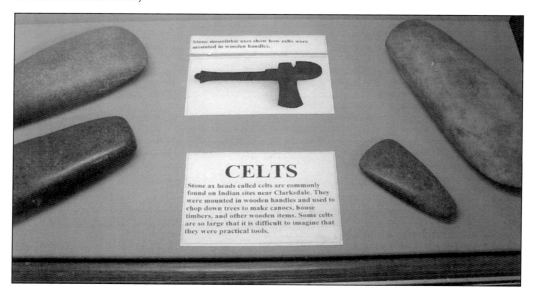

Two

EARLY SETTLERS AND PLANTATIONS

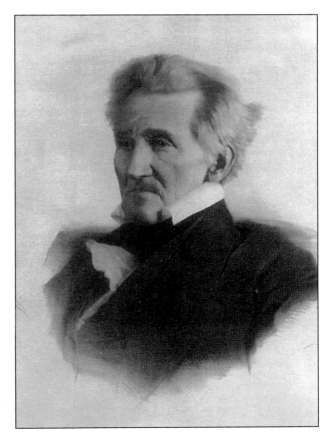

Pres. Andrew Jackson (pictured) and his son Andrew Jackson Jr. purchased Halcyon Plantation, containing 1,100 acres, before 1839. Their holdings reached about 3,000 acres. This and other riverfront plantations suffered frequent flooding, which lowered their financial value. Also, Jackson's son exhibited poor management and irresponsible spending, endorsed friends' bad debts, and had staggering debts of his own. Jackson Jr. owned the plantation for a while after his father died, but he sold most of the acreage in 1858 to Enoch Easley. (RH.)

Col. John Oldham bought his property shortly after the Treaty of Dancing Rabbit Creek through an original land grant. According to the writings of Louise Stovall d'Oyley, Oldham's great-great-granddaughter: "The plantation was originally called Port Royal and was near, where legend has it, the last of the area river pirates were forced to walk the plank into the Mississippi River. The town must have joined them there for Port Royal disappeared and no one knows just where it went or where it was. The plantation is now called Prairie for the big field, the core of the place, which was cleared at a time beyond the memory of man. It was probably farmed by Native Americans. My house was built in 1847. The first one burned down. It is built of bricks made on the place and timber cut from the woods. Because it is protected by a private levee, it has never been under water. Prairie Plantation produces cotton, soybeans and peanuts. Inside the boundaries is a game preserve which is host to wild turkeys and deer." (Shonda Warner.)

Col. William Howard Stovall II began building Stovall Plantation after his marriage to Louise Irene Fowler, granddaughter of Col. William John Oldham, owner of Prairie Plantation. Oldham bought his land shortly after the Choctaw Indians surrendered their land under the Treaty of Dancing Rabbit Creek in 1830. Before his marriage in 1866, Stovall had been a lawyer in Memphis and a Civil War veteran, having served as adjutant to the 154th Tennessee Regiment. He played an important part in the organization of the upper Yazoo Levee District, serving as a leader and president of its commission. Following in the footsteps of their ancestors, later generations used determination and innovation to produce cotton crops of better quality and increased yields. Early on, Stovall supplemented row crop farming with a successful cattle operation, later leasing levee board land for grazing. (Both, SF.)

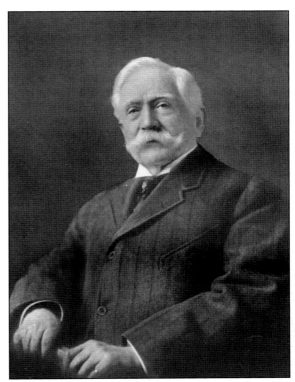

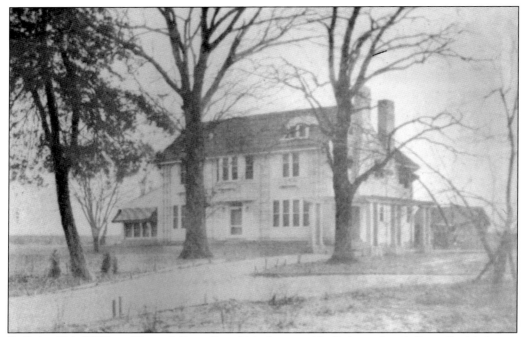

Built by Col. William Howard Stovall and his future wife, Roberta Lewis Stovall, this home burned down during the filming of *Cabin in the Cotton* (1932), starring Bette Davis and Richard Barthelmess. With the fire raging, the film crew saved the dining-room furniture. This residence faced Stovall Road.

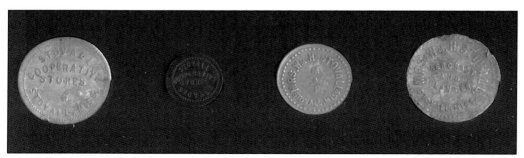

Many plantations across the South had their own script and coinage, which was used to pay laborers or tenants and could only be used in that plantation's commissaries or stores. One reason for this practice was to keep the people on the plantation. Shown here are various denominations of coinage used on Stovall Plantation. (SF.)

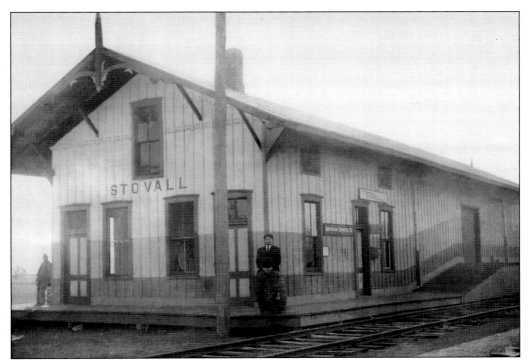

When the Louisville, New Orleans and Texas Railroad came through Coahoma County, a deal was made with the plantation owner to provide a depot on the property. It is not known how many years the trains actually stopped here, although the depots usually handled mail and were on road maps. (SF.)

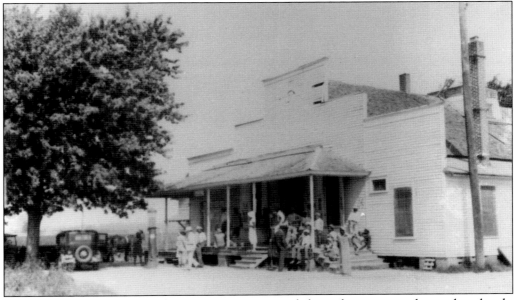

The Stovall Store on Stovall Plantation was an extremely busy place on rainy days and weekends. Since they were paid in script or tokens, tenants could only spend their pay there. In later years, the store became a place to stop for hunters and fishermen and those traveling on Highway 1. (SF.)

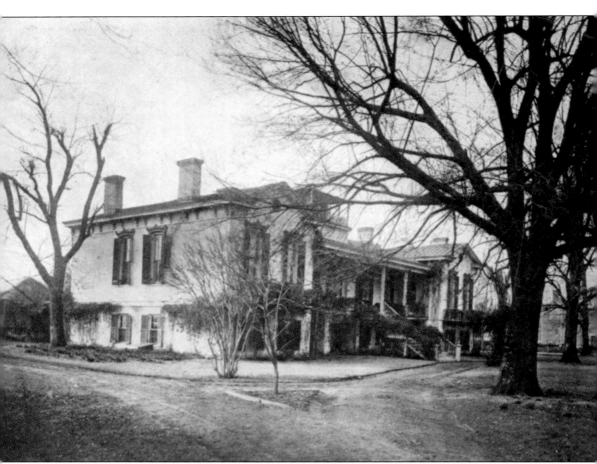

The Bobo home was one of the first permanent residences to be erected in what is now Clarksdale. Spencer A. Bobo, first of the family to settle here, started the house in 1834. It was finished by his son Charles in 1856. The home, resembling the White House of the Confederacy, was built by slaves on the plantation. Spencer's wife was Louisa Sims. Fincher Gist Bobo, brother of Spencer, arrived from Panola County not long after his brother. Spencer's first home was a cabin with a dirt floor. It took him about 20 years to accumulate the funds to build his family a nice home. He later owned a vast amount of land, stretching along the west bank of the Sunflower River and running for several miles from Honey Hill Plantation on New Africa Road to what is now the Clarksdale Country Club. Today, Clarksdale High School stands on the former location of the Bobo home. The family burial plot is fenced off from the school grounds.

Fincher Bobo married Sara Eager, and the couple had a son, Robert Eager Bobo, in 1842. He grew up in a virtual wilderness. As a young man, he experienced hunting on a large scale, as wildlife was abundant. He joined the Confederate army about 1861 and returned home after serving four years to find much of the county under water. To find a spot of dry land, he got into a canoe and started south. He did not encounter dry land until he reached the place where Bobo, Mississippi, is now located and acquired the property. Through hard work and financial planning, he expanded the space into 2,000 acres. Robert Bobo loved bear hunting. Although he welcomed hunters from all over the country, he avoided publicity and talking about himself. Historians and descendants have preserved the records of this fine gentleman and sportsman of polite society, and a recent book has been issued, *The Bear Hunter: The Life and Times of Robert Eager Bobo in the Canebreaks of the Old South*, which provides the in-depth story of this remarkable man. (JB.)

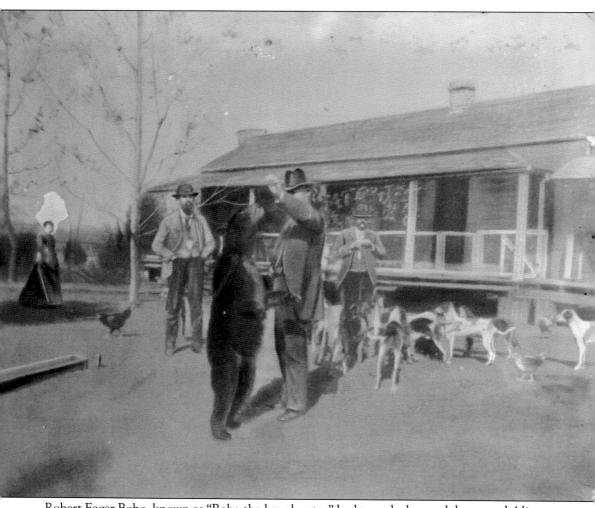

Robert Eager Bobo, known as "Bobo the bear hunter," had tamed a bear cub he named Alice to help train young dogs for hunting. Bobo reportedly had 45 to 80 dogs, depending on who was telling the story, and most were Walkers and Redbone hounds. He would put a collar around the bear's neck, tie him to a wagon, and lead him through the woods, leaving a trail for the puppies to follow so they would chase the bear. When he wanted to show off his dogs or get ready for a hunt, Bobo would take down his hunting horn and blow it long and loud. The pack of dogs would come running from every direction, howling and jumping and anxious to begin the hunt. Some hunts would last for weeks, so supplies and tents with mosquito nets were loaded on wagons, one for each hunter with an attendant for each. In one report, it is noted that Bobo and his party killed 304 bears, 54 deer, 47 wildcats, and nine panthers in one year. (JB.)

Edgar Lee Anderson was the son of William Patrick Anderson and Lucretia Greenwood Anderson. His parents came into the county in the early 1870s from Copiah County with Lucretia's brother C.W. King and acquired a large tract of land. At the age of 21, Edgar Lee became a member of the family firm. This company amassed a great fortune, including land holdings, and entered established business firms in Clarksdale and organized new ones. In the early 1890s, the company built the first Alcazar Hotel, with 40 rooms. In 1915, a larger Alcazar was built. In the 1890s, the Anderson family built the Clarksdale Theatre, a better choice than Grange Hall, with plays like *East Lynne* and *Ten Nights in a Barroom*. Their theater showed dramas, musical comedies, and light operas. King and Anderson owned numerous rental properties and were affiliated with William R. Moore Dry Goods Company in Memphis, Delta Grocery & Cotton Company of Clarksdale, and Johnson-Harlow Lumber Company of Clarksdale. Anderson was vice president of the Planters Bank, which had the most phenomenal growth record in the history of banking in the United States. Anderson and Mamie Brown Colbert were married in 1902 and had two sons, Edgar Lee Jr. and William King Anderson.

The initial King and Anderson firm was a partnership of C.W. King (pictured) and his sister Mrs. William Patrick Anderson, with E.L. Anderson becoming a partner at 21 years of age. The King family resided in an early plantation home until around 1900, when they built a home in Clarksdale near St. Elizabeth's Catholic Church. The Kings and Andersons began farming near the Elkhorn residence, where Federal troops had been stationed during the Civil War. In 1952, their plantation had grown to 20,000-plus acres due to the addition of Elk Horn Plantation and its house. Elk Horn had belonged to the family of Mrs. E.L. Anderson Sr., who was born in the house there in 1873. Her parents were Virginia Dickerson Brown and William Newton Brown. The Dickerson family had settled in Coahoma County around 1837. In later years, besides immense acres of cotton, beans, and other crops, King and Anderson had one of the largest dairy operations in the state. Raw milk, from a herd of Holsteins, was sold at the plant to Denton's of Cleveland.

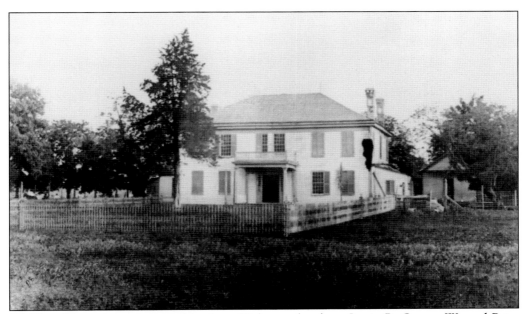

Elk Horn Plantation was owned by three Dickerson brothers: Levin P., George W., and Peter Cottman. The original residence was built in the 1830s and remodeled after 1849. This remodeled home still stands, looking much as it did then. The lower floor has a big hall running the full length of the house, with two large rooms on each side. Mrs. E.L. Anderson was the granddaughter of Peter Cottman Dickerson. (GA.)

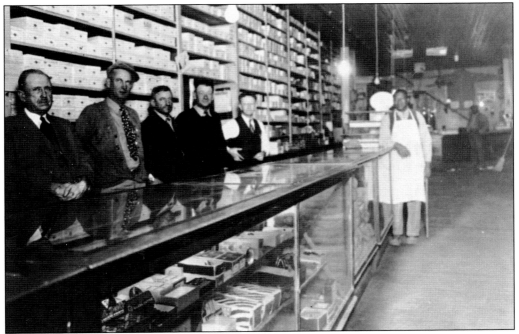

This is the interior of the King and Anderson commissary. With its wide variety of merchandise for sale, it resembles a general store. Posing here are, from left to right, E.L. Anderson Sr., Lewis Bonnett, Orrin Sullivan, R.P. Davis, John Roland, and Dan Anderson. (GA.)

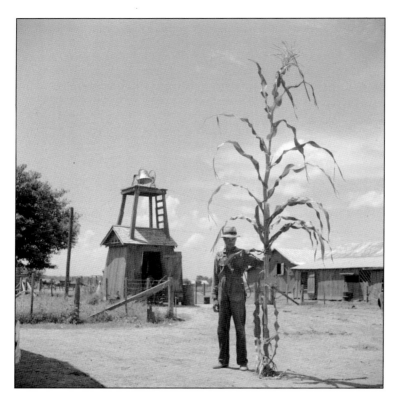

In the years before soil enhancements or specific varieties, the yields of corn could grow to this size. In the background is the plantation bell, used to indicate the start of work, the noon hour, and quitting time. These bells could be heard over long distances. (LC.)

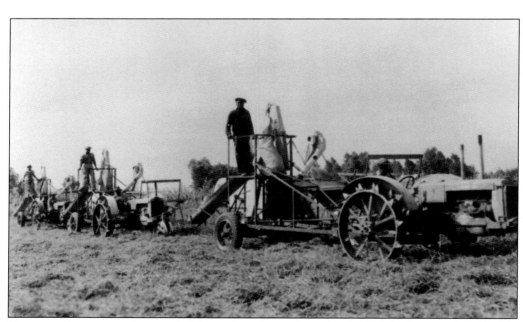

Tractors are harvesting wheat on the King and Anderson plantation in 1935. At the time, these tractors and the equipment would have been the latest models available for this type of work. (GA.)

King and Anderson Plantation became a combination of farming operations owned by three corporations headed by E.L. Anderson Jr. (pictured), Chauncey G. Smith, and William King Anderson. They jointly owned interests in real estate and other investments and were engaged in other business activities. Their careers, as well as those of their family members, have greatly benefited Clarksdale and the Delta.

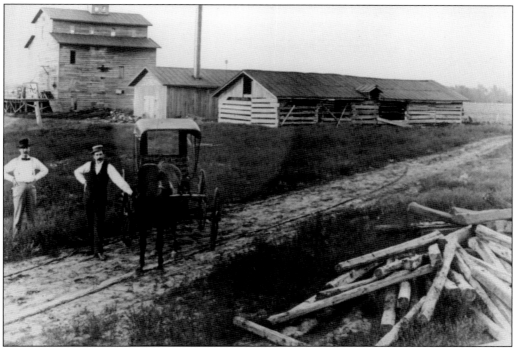

A tornado hit King and Anderson's Elkhorn Plantation in 1915. Here, Bob Coleman and his son Ben survey the damage. The barn in the background is called a "lookout barn." Scales for weighing cotton can be seen on the platform in front. The building with the long pipe extending from the roof is the steam-powered gin. The oldest gin in the county, it was built about 1850. (GA.)

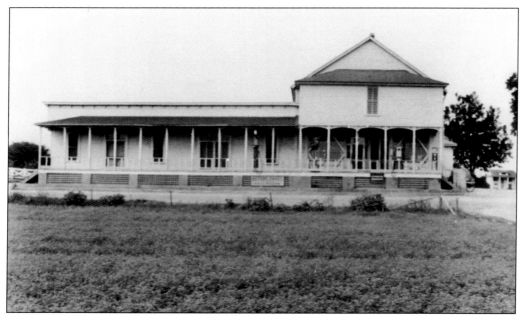

This King and Anderson commissary served tenant farmers and others from a large area. The building was torn down some time ago. To the back of the building, on the right, is the children's playhouse. (GA.)

The old First Methodist Church of Clarksdale was moved to Dickerson by Edgar Lee Anderson to be used as the African American church in the area. Almost all plantations provided churches for tenants. (GA.)

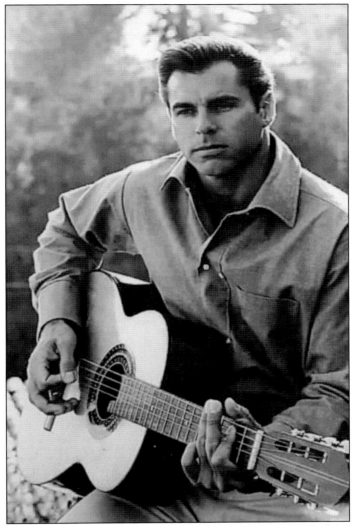

E.L. "Andy" Anderson III grew up on his family's plantation near Clarksdale listening to the Delta music outside the family store on Saturday nights. The blues would some day influence his music, and he formed a band, the Rolling Stones (not to be confused with the later British band). The Rolling Stones, which became the most successful local band in the 1950s, came together at Mississippi State College in 1953 with three freshmen, Anderson, William "Cuz" Covington, and Joe Tubb, playing jam sessions in the dorm, Old Main. After Bobby Lyon, James Aldridge, and Roy Estess joined the group, they played around campus and then were in demand at other campuses and neighboring towns. Their music was a totally new and exciting sound, mixing blues, country, and gospel. It could keep an audience on its feet and girls screaming for the entire performance. After winning the Mid-South Talent Contest in Memphis in 1957, the Rolling Stones signed a contract with Felsted Records and were on their way with the recording of "Johnny Valentine" and "I-I-I Love You." It was the first rock 'n' roll record to be distributed worldwide. When "Johnny Valentine" was released in Jackson, the Rolling Stones was the first rock band to be honored with a parade down Capital Street. The group recorded hit 45s with Sam Phillips at Sun Studios in Memphis. Their name would be taken away by the British Stones. Later, Anderson formed the Dawnbreakers, which was also very successful. (Andy Anderson.)

Rufus W. Hall, a farm manager/overseer for Irvin Plantation, owned by King and Anderson, was employed by Cecil King in 1907 and remained there until 1922, when he and his family moved to Paris, Texas. He returned to the county in 1926 and managed Green Grove Plantation at Rena Lara. Hall was married to Alice Gann of Coldwater, Mississippi. Their daughter Ethel married Walter O. Birdsong Sr. of Clarksdale. (RH.)

William Walker Hall (seated, right), farm manager/overseer on Prairie Plantation owned by King and Anderson, moved there from Coldwater, Mississippi, in 1905. He and his older brother Rufus acquired their extensive agricultural knowledge, including ginning, from their father, Thomas Hall, of Coldwater. Walker, a skilled horseman, broke and trained all of his horses. He was married to Mary Lee Gaines (seated, left). (RH.)

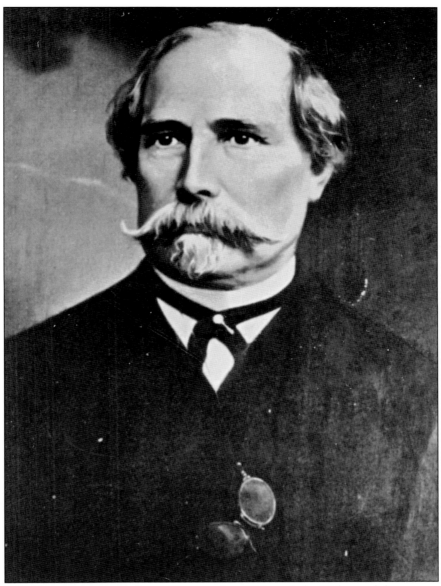

James Lusk Alcorn came to Coahoma County after 1844, settled at Delta, and then opened a law office at Friars Point. His law practice flourished, and his ownership of Delta land increased. By 1860, he owned close to 100 slaves. He represented Coahoma County in state government in the 1840s and 1850s. Alcorn was made a brigadier general of the Army of Mississippi in the Civil War and took part in organizing state troops for duty, but Pres. Jefferson Davis denied his command. Alcorn maintained his wealth during the Civil War by trading cotton with the North. After the war, he was said to be one of the 50 wealthiest men in the South. He was elected Republican governor in 1870 and resigned in 1871 to serve as a US senator. Alcorn supported a new college for African Americans, now known as Alcorn State University. However, his objections to a state civil-rights bill were well known, as was his unwillingness to support or appoint African American officers. Alcorn propelled the efforts for the levee system, and legislation governing the building of levees was enacted. He was the first president of the levee board.

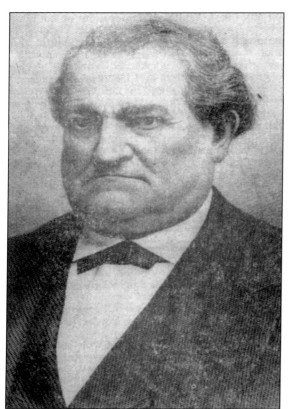

Known as the world's largest cotton planter, Edmund Richardson owned vast holdings in Mississippi, Louisiana, and Arkansas. He was an early landowner in Coahoma County, with land near the river. After the Civil War, he acquired more land, eventually owning 50 plantations across three states. He in turn required a large supply of labor. Richardson made a deal with the federal authorities to use convict labor, mostly African American vagrants, on the Mississippi Delta plantations. (RH.)

Gen. Nathan Bedford Forrest purchased almost 2,000 acres of land in the 1850s (the shaded area on this map). He purchased another 1,500 acres just before the Civil War. Due to financial reverses, he relinquished that land about the time the war ended.

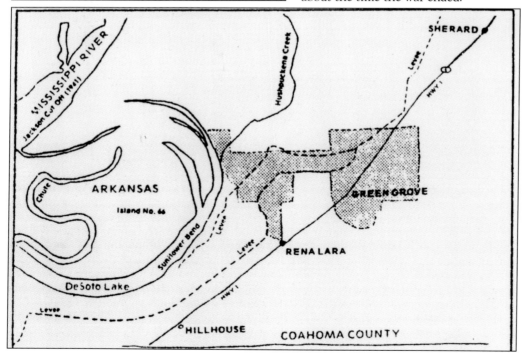

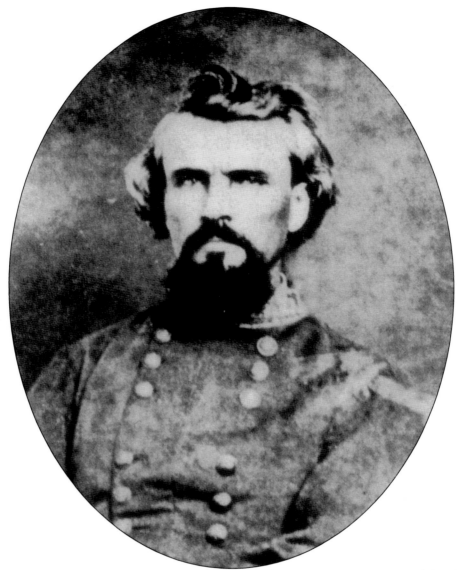

In 1859, Gen. Nathan Bedford Forrest moved his wife, Mary Montgomery Forrest, and their family to Coahoma County, where he became a successful cotton planter on the land he owned. The late John Holmes Sherard described Forrest's home as a six-room dwelling that was not beautiful, but comfortable. Sherard also said there were slave dwellings a short distance behind the house; the 1860 census indicates he had 36 slaves. In June 1861, Forrest enlisted as a private in White's Tennessee Mounted Rifles and rose to lieutenant general in the Confederate army. Forrest has become recognized as probably the greatest cavalry leader in history. Gen. William Sherman said during the drive against Atlanta, "We must destroy Forrest if it costs ten thousand lives and breaks the treasury—keep him away from me." Returning to his plantation after the war, about 20 of Forrest's former slaves returned with him, and one of the federal officers became his partner in the planting ventures. Forrest set about repairing his neglected plantation after both Union and Confederate troops had stripped the place of equipment, livestock, and crops. The expenses of rebuilding contributed to a financial decline. (RH.)

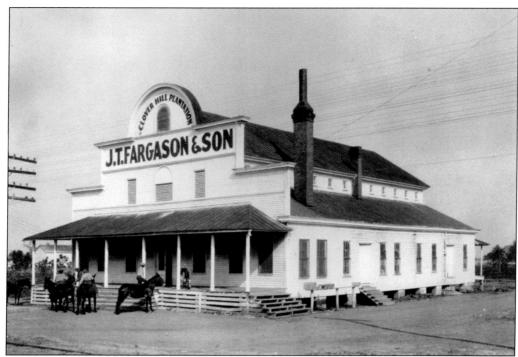

The J.T. Fargason & Son commissary on Clover Hill Plantation was built about 1885 and remained a landmark for well over 100 years. The main highway from Clarksdale to Memphis once passed this building. The commissary drew customers from the plantation, residents, and travelers. It had an inventory much like a general store. Years later, the commissary burned down, perhaps from a lightning strike. (JSD.)

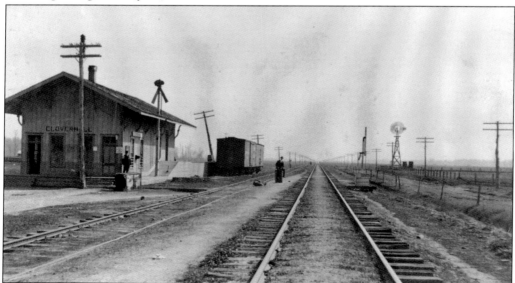

Clover Hill Plantation was established in 1880 by J.T. Fargason of Memphis. He was the head of a wholesale grocery business and a cotton factor. He also owned Richland Plantation near Clarksdale, a plantation at Eylau, Tennessee, and the Sunflower Oil Mill in Clarksdale. (JSD.)

Fargason's major interest was at Clover Hill, named for a nearby clover-covered mound. As with future generations, he was progressive in seeking to diversify beyond the row crop operation. About 1890, a 40-acre pecan orchard was set out, and it was expanded in later years. At that time, the land was dedicated to cotton, with ample acreage in feed crops for livestock. Corn, soybeans, and rice have also been grown on this land.

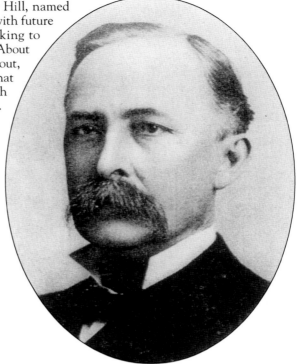

As the railroad expanded, so did the number of depots with stops, and this called for a boardinghouse near the depot in Clover Hill. Fargason, looking to future investments, began to grow black locust trees for fence posts on a large scale, as those posts were the finest non-rotting posts known. In 1935, 3,000 trees were planted. Cattle and hog projects were also undertaken at Clover Hill. (JSD.)

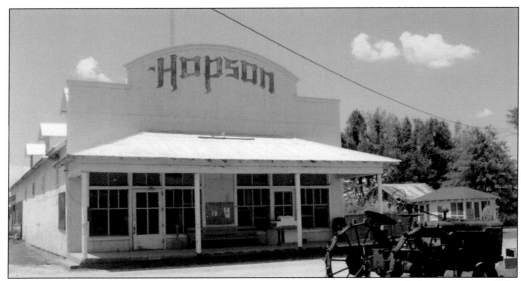

Only two land entries are recorded in Coahoma County in 1834, one of them to Howell R. Hopson for a tract of land in the extreme southeast corner of the county along the Sunflower River. When cotton was first grown at this location, it was a crop undertaken by man and mule. Hopson could not know that one of the most important innovations of cotton farming would take place here.

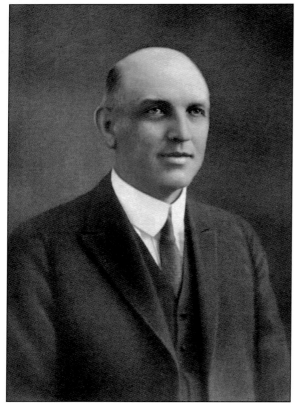

Howell Harrison Hopson, born in 1875, was the son of pioneer settlers. He returned from college in Kentucky at age 21 to begin his career as a planter on his own land and was highly successful. No one surpassed his ability to handle laborers, organize them for work, and inspire them with absolute confidence in his honesty. He also had a financial interest in some of the best business concerns in Clarksdale. (*Mid-South and Its Builders.*)

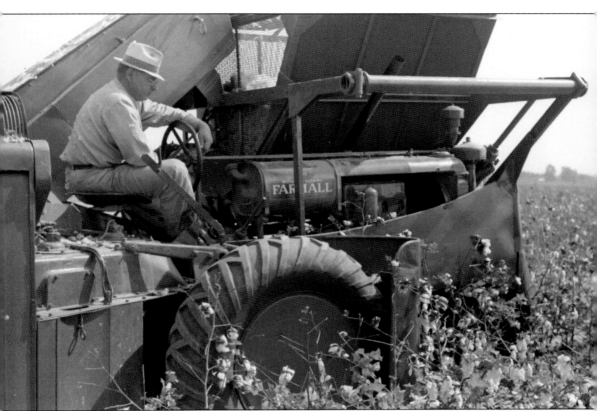

Experimentation with cotton pickers was intense in the late 1930s. During the fall, when the bolls opened, German mechanical engineers employed by International Harvester would travel from Chicago to experiment in the lush fields of Hopson Plantation. The single-row picker shown here is bolted on a Farmall tractor. Technology would replace it very quickly with a stand-alone picker. Farmers would not have to face labor shortages during peak times, as mechanization required few people. On the other hand, it was estimated that five million farmworkers would be replaced by tractors, implements, and mechanical pickers across the South in a few years. It was predicted that the displacement of so many people would affect the entire nation. Most of the people were totally unprepared for life off the farm, but they would be expected to find a new way of life. The country was attempting to return to a normal life after World War II, and its interest was elsewhere. It paid no heed to this dire situation affecting African Americans in the South, and no government entity was ever involved. (LC.)

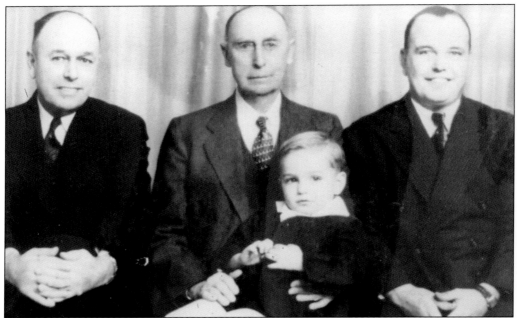

Seated here are, from left to right, John Holmes Sherard Jr., John Holmes Sherard Sr. (holding John Holmes Sherard IV), and John Holmes Sherard III. Sherard Sr. was orphaned when he was young and was reared by his uncle Joseph Arrington. They came from Livingston, Alabama, in wagons pulled by oxen and were accompanied by a small number of African Americans, who had been his parents' slaves. Descendants of those former slaves continued living on the plantation, and their loyalty to the Sherards is well known. (HP.)

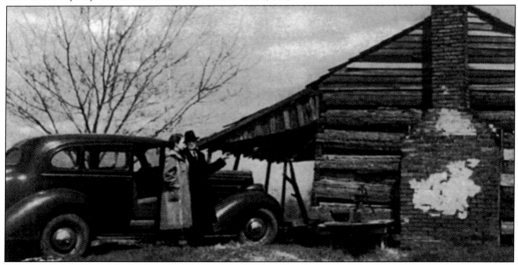

John Holmes Sherard's first Delta home was this modest log cabin, built in 1872. Fighting swamp fever, pestilence, and continued flooding until his plantation encompassed 6,000 acres with 2,000 residents, Sherard became a model of humanity and philanthropy. The plantation had a general store, post office, railroad station, church, and school. The residents were attended to by two physicians. In 1890, seventy-five acres of paper shell pecans were planted, and Sherard pecans became internationally known. (HP.)

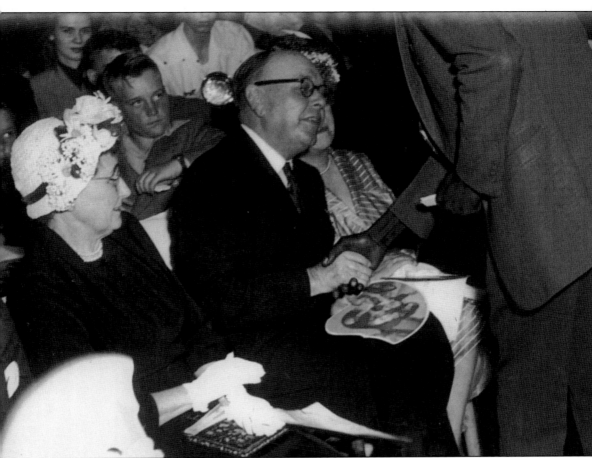

John Holmes Sherard's deep religious convictions led him to work untiringly to establish a Methodist hospital in Memphis, and he held the office of president of the board of trustees until his death. His descendants continued to serve on that board. He made another great contribution in his concern for the orphans of Mississippi, with his association of 40 years as president of the board of the Methodist Orphanage in Jackson. He realized one of his dreams when Sunflower Landing was designated as the site of De Soto's discovery of the Mississippi River. It was Sherard's research and historical material that helped influence the congressional De Soto Expedition Commission and its subsequent action. In 1950, a heartwarming celebration was held on Sherard Plantation, organized by members of African American tenant families who had worked for the Sherards for generations. The celebration was a tribute for his fair treatment and benefactions. The families also wanted to thank the Sherards for their assistance in founding three Baptist churches and a school on the plantation. Pictured here are, from left to right, Mrs. E.L. Rawles and Mr. and Mrs. J. Holmes Sherard. (HP.)

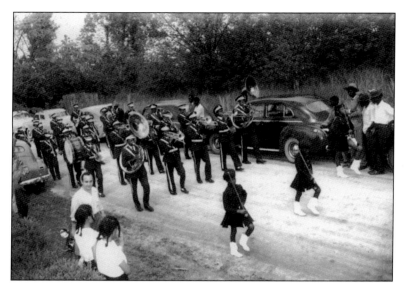

The Coahoma County Agricultural High School band escorted the Sherards from their car to the Mount Zion Baptist Church, one of three African American churches on the plantation, to attend their tribute. (HP.)

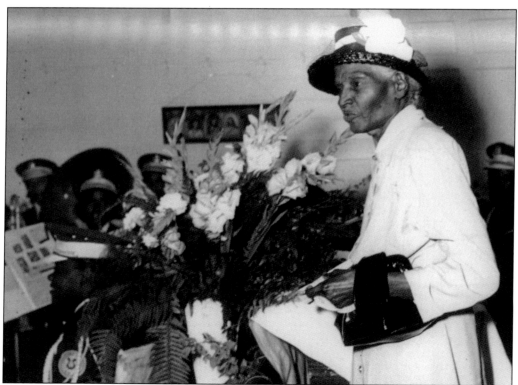

Among the comments from those honoring the Sherards were the following: "I've known Mister Holmes all his life, and I knew his Mammy before he was born, before I came to Sherard from Alabama in 1875. He's been a mighty good friend of the colored people." Another speaker said, "I've been knowing Mister Holmes since he was a boy, and I've never known a better white man." (HP.)

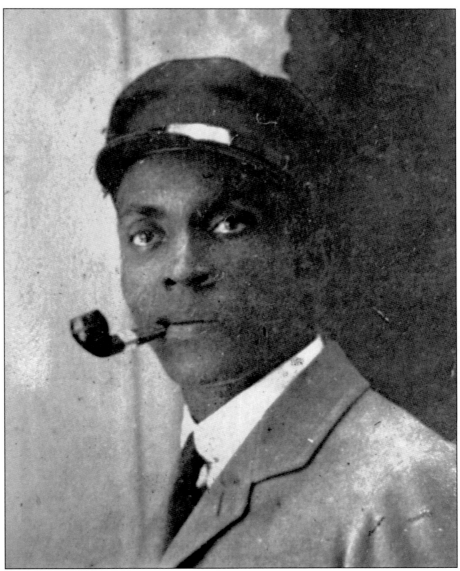

Frederick Bruce Thomas was born in the Hopson Bayou neighborhood of Coahoma County in 1872 to former slaves who had become prosperous farmers. After a wealthy white planter tried to seize the family's land, Thomas left the South and worked as a waiter and valet in Chicago and Brooklyn. In 1894, he went to London, traveled throughout Europe, and went to Russia in 1899. Moscow became his home, and he renamed himself Fyodor Fyodorovich Tomas. By dint of talent, hard work, charm, and guile, he became one of the city's richest and most famous owners of variety theaters and restaurants. The Bolshevik Revolution ruined Tomas, and he barely escaped with his life and family to Turkey in 1919. Starting with just a handful of dollars out of the millions he had lost, Tomas made a second fortune in Constantinople by opening a series of celebrated nightclubs that introduced jazz to Turkey. However, because of American racism, the xenophobia of the new Turkish Republic, and his own extravagance, Tomas fell on hard times, was thrown in debtor's prison, and died in Constantinople in 1928. A book about his life, *The Black Russian*, has been written by Vladimir Alexandrov. (LC/Vladimir Alexandrov.)

Born in Panola County, Arthur Jenkins Moseley found at the age of 25 that he desired the more strenuous life of the Delta, just beginning its astounding growth. He was in charge of the large planting and mercantile interests of Mrs. L.E. Bobo at Lyon and then became a planter on his own account. He was a very industrious young man, and Moseley's business grew from the start. He soon acquired a fortune. He felt that Coahoma County was the finest county in the world, not only in which to live but also in which to invest. In addition to planting, he was a stockholder and director in Planters Bank, the Clarksdale Savings Bank, the Johnson-Harlow Lumber Company, the Clarksdale Machinery Company, and the Coahoma County Milling Company. He was vice president of the Delta Grocery & Cotton Company and of the Delta Hardware & Implement Company. Moseley and Hettie Bobo married in 1895 and had a daughter, Louise. Arthur Moseley was well known and well liked by all who knew him.

Three

CLARKSDALE AND COMMUNITIES

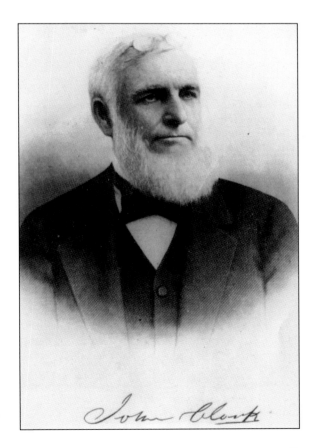

John Clark, for whom Clarksdale is named, was born in England in 1823. His father died of yellow fever in New Orleans when Clark was around 15. A friend of his father, Edward D. Porter, from Coahoma County, was in New Orleans, and the two of them came up the river to Port Royal. Young Clark formed an interest in Porter's timber business and became a partner. According to John's son Walter Clark, the first land John acquired was 160 acres in the northern part of what is now Clarksdale.

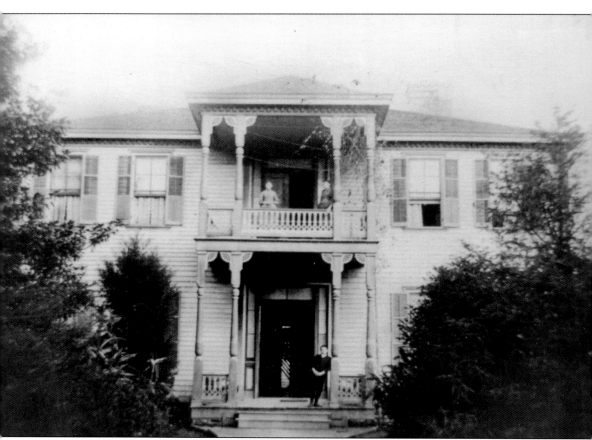

John Clark and his wife, Eliza Jane Alcorn, sister of James Lusk Alcorn, first lived in a log cabin and then in 1858 built a larger home near the Sunflower River. The architect, who was from Philadelphia, would not use slave labor, so workmen came from the North. Before the house was finished, the workmen received news of an impending Civil War and left for home. Clark continued to increase his land holdings until the Civil War. In 1869, he laid out the town of Clarksdale, chartered in 1882, which had been named by Mrs. Eliza Clark and Mrs. C.W. King while standing on the little hill, now called Cutrer Hill. He began to sell lots in Clarksdale and invested the funds in more land. John Clark was the first president of Clarksdale Bank & Trust Co. and a director of the Brick Manufacturing Co. He served as mayor, tax collector, and councilman and owned and operated a flour mill, furnishing wheat from his own land. (Paul Clark/CPL.)

The battle over the county seat raged for years between Friars Point and Clarksdale. In 1891, political leaders of the county met in Memphis to attempt a compromise. The decision split the county, and two judicial districts were formed. Friars Point was the First Judicial District, and Clarksdale the Second Judicial District. This action would remain in effect for 40 years, and then Clarksdale would be the official county seat. In 1894, Clarksdale erected a courthouse at a cost of $19,050.

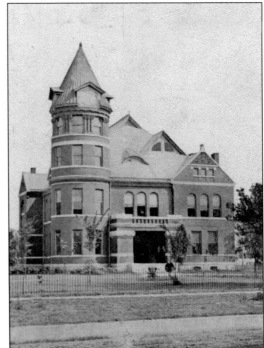

Friars Point had also completed its new courthouse by 1894. The buildings had a similar look, but the turret on the Friars Point courthouse was square while Clarksdale's was round. (MMP.)

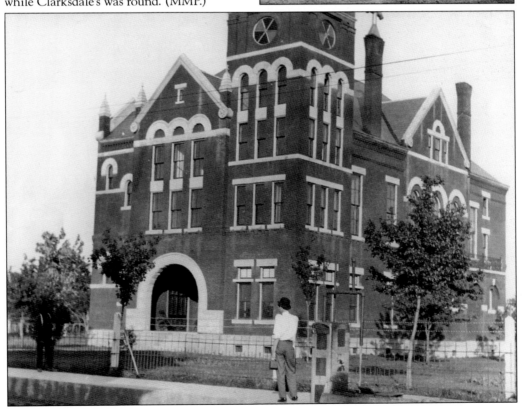

43

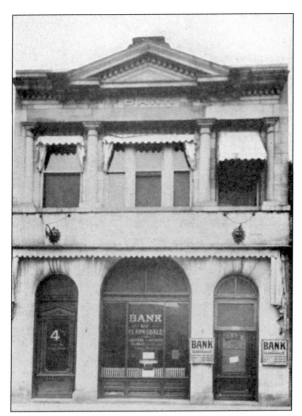

In 1900, Edward Peebles Peacock, who had been a planter, saw the need for a bank for the planters he worked with at Newburger Cotton Co. When the Bank of Clarksdale opened, it operated out of the Dolan Building at 214 Delta Avenue and soon moved into the new building (at left) at 224 Delta Avenue. When it outgrew that space, a new building was erected at the corner of Yazoo Avenue and East Second Street.

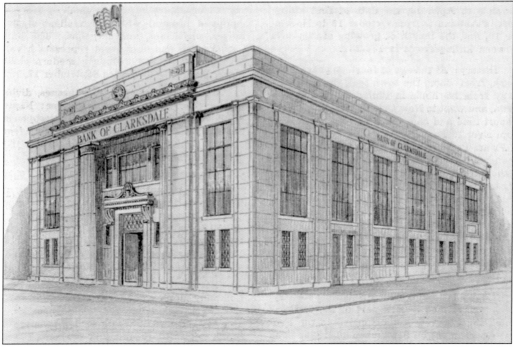

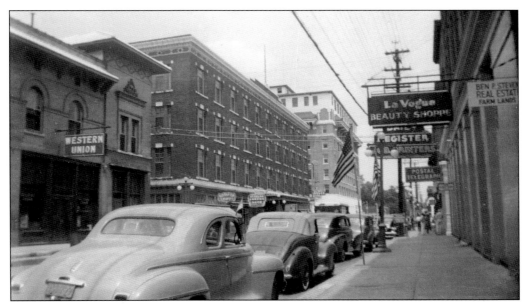

The Alcazar Hotel (left) was a two-story brick building erected in 1895 by Clarksdale, King & Anderson, a real estate partnership of Cecil W. King and brother-in-law William P. Anderson, owners of King & Anderson Plantation. This hotel became the center of Clarksdale's social life.

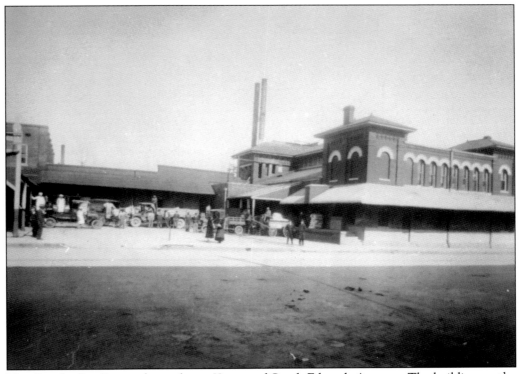

The Crawley Ice Co. was located near Yazoo and South Edwards Avenues. The building on the right appears to be the original Alcazar Hotel. (Mrs. Tom Ross/CPL.)

The Mississippi River controlled many aspects of early life for inhabitants of the county, particularly the shipping of logs, lumber, and cotton. Frequent flooding made roads impassable, and rivers and bayous often overflowed their banks, so getting wagons or small boats to the river was a test of endurance. Many unsuccessful efforts were made to establish significant rail service for the county. In 1883 and 1884, following an inland path, M&V Railroad constructed a new rail line stretching from Memphis to Clarksdale, Vicksburg, Baton Rouge, and New Orleans. The railroad changed the landscape of the Delta, as towns near the tracks grew and others diminished or ceased to exist. No longer was the Mississippi River the only avenue for shipping and as a means of travel to and from Memphis or points south. Clarksdale flourished and gained other lines as it became a breaking point for many railroads across the Delta and the state.

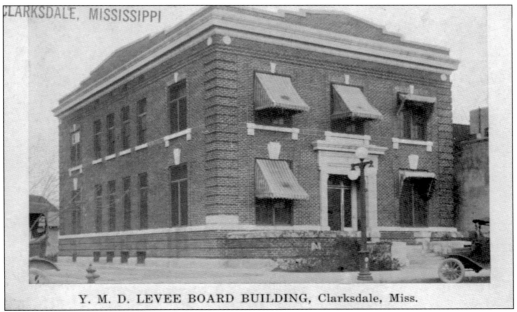

Y. M. D. LEVEE BOARD BUILDING, Clarksdale, Miss.

The Yazoo–Mississippi Delta Levee Board building, erected in 1912, stands as a monument to the constant battles with the Mississippi River and interior rivers and streams, as well as the efforts of many to confine the river to a channel, using levees and other improvements that have provided safety and peace of mind for citizens of the Delta's 10-county district. The 1897 break at Tunica was the last crevasse in this levee system.

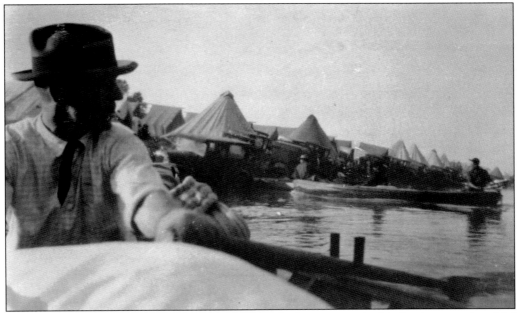

Thomas Gregory Dabney, described as the father of the levee system in this district, served as chief engineer from 1884 to 1920 and then as consulting engineer. Levee projects often took months to accomplish. Laborers lived in camps to stay near the job, as transportation to and from the site was not feasible. (MMP.)

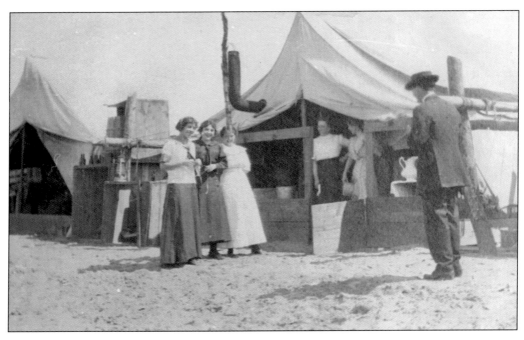

Wives would accompany their husbands during the months of levee building and keep house in these tents. The levee camps were like small towns. Other housing for levee labor was provided on barges, which could easily be moved to other work sites. Additional barges were attached for supplies and equipment. (Both, MMP.)

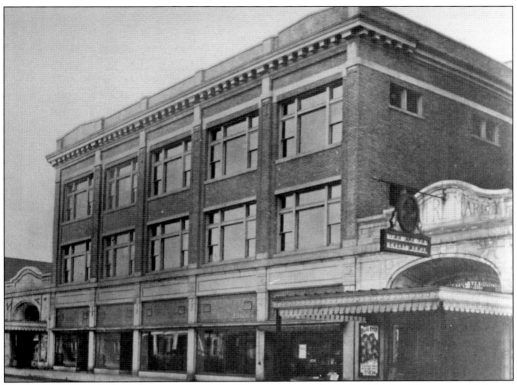

Located on Yazoo Avenue was the Loeb Building. To the right is the Marion Theatre, which was an addition to the McWilliams Building. The name of the theater is carved atop the building.

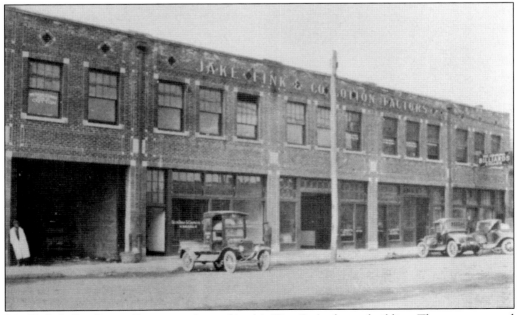

Jake Fink & Co. Cotton Factors was located in this King & Anderson building. There were several buildings in the city constructed and owned by King & Anderson.

Earl Leroy Brewer was elected governor in 1911. W.C. Handy played for his political rallies. Brewer graduated from the University of Mississippi with a law degree, served in the state legislature, and was a district attorney. Brewer instigated the first state child-labor law. In 1919, he sold his 2,200-acre Omega Plantation to C.G. Bobo. (MMP.)

This second Clarksdale home of the Brewers was built in 1917–1918. It was located at the corner of John and Clark Streets.

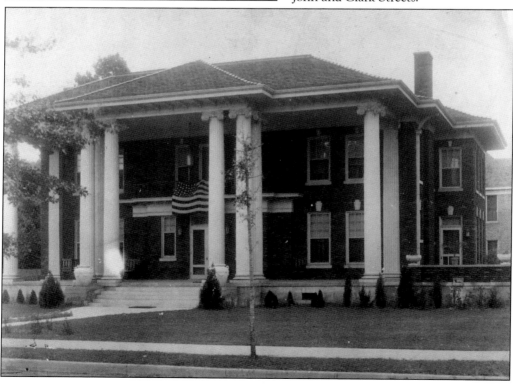

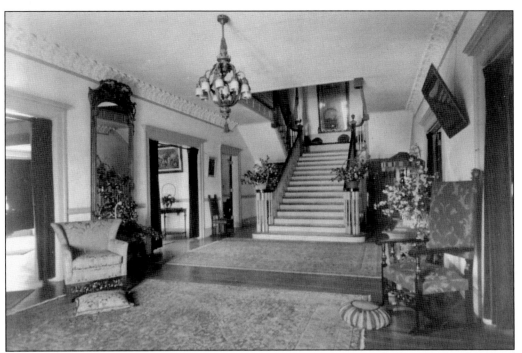

The grand reception hall of the Brewer house is pictured as it appeared when the family moved into the residence. Brewer's library was behind the wall to the left.

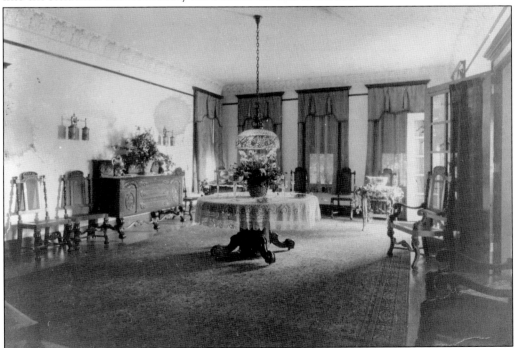

Large windows and doorways flooded the house with light, as shown in the dining room. In addition, the City of Clarksdale installed electricity beginning in 1900.

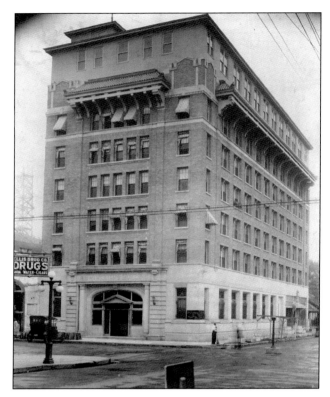

Completed in 1917, the McWilliams Building illustrates R.N. McWilliams's faith in the progress of the city and county. The first floor housed Delta Bank & Trust Co., and other floors were occupied by professionals. The uppermost story was designed as a roof garden with a dancing pavilion. Noted at the time as Clarksdale's first skyscraper, it has been the city's most imposing structure for 98 years.

R.N. McWilliams, after completion of the McWilliams Building, constructed an addition to the building for Theatre Marion. There was seating for 1,000, and it contained a $7,000 pipe organ. The theater was named for his daughter Marion McWilliams. Fire gutted this building in 1921 or 1922. The carved signage for the venue remains over the Paramount Theater. (Flowers family.)

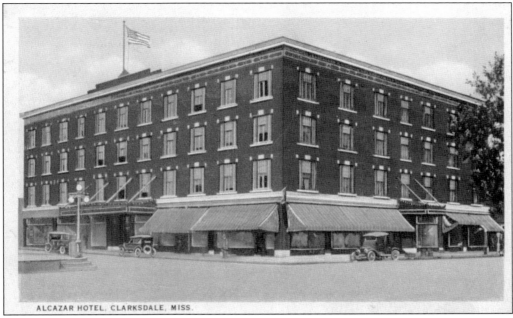

ALCAZAR HOTEL, CLARKSDALE, MISS.

The new Alcazar Hotel was built in 1914–1915 with three times the hotel rooms as the first, connected by a second-floor walkway, and was expected to meet the needs of Clarksdale's economic boon. Charles O. Pfeil of Memphis was the architect of what was described as the most modern hotel in Mississippi. Off the lobby there was a restaurant, businesses, and WROX radio station. Around the perimeter were 11 storefront bays. (PC.)

Land was developed west of the Sunflower River in the early 1890s, and river crossing became a problem. The Sunflower River was much wider, and the footbridge that spanned it just behind where the jail is now and up to John Clark's home was covered during high water. This photograph was taken from the footbridge, looking south. Some people crossed on the railroad bridge, which was an unsafe choice. (PC.)

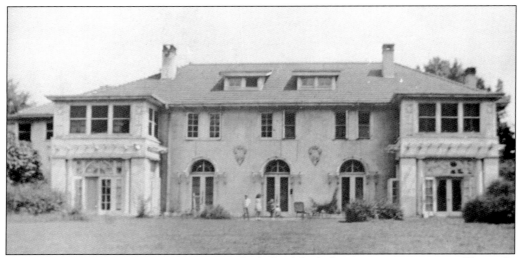

In 1916, J.W. Cutrer, a prominent attorney who helped draft the state constitution, and his wife, Blanche Clark Cutrer, daughter of Clarksdale founder John Clark, built their Italian Renaissance villa. John Clark had previously constructed his family home here, and it was moved on logs to a lot to the east so his daughter might have her home on the hill overlooking the Sunflower River. This house became a social and cultural center for the area, hosting masked balls, lawn parties, and orchestras. International celebrities and notables were among the guests. For Clarksdale, this house and Tennessee Williams plays are inseparable. Young Williams visited the house with his grandfather Rev. Dakin Williams while staying with him. The playwright probably soaked up every conversation and all the gossip he heard, as the Cutrer family appears in many of his works. (Above, courtesy of Liz Rogers Collection; below, CPL.)

J.W. Cutrer hired Bayard Cairns, a noted architect from Memphis, to design his home, sparing no expense for the building or the contents. Across the road and a distance from the house, near the Sunflower River, were the servants' quarters and stables, as stated in a later rental agreement. Cutrer was from Pike County, Mississippi, and graduated from the University of Mississippi Law School. (Rev. John Cutrer Smith.)

Blanche M. Clark married J.W. Cutrer in 1887, and they had three children: John, who died at Moon Lake; Ann Blanche, who married Edward Smith and lived in the John Clark house; and Elise, who married Howard Shields. Blanche thoroughly enjoyed her home and the lavish galas she held. She may have furnished her home and acquired themes for her parties from her world travels. (Rev. John Cutrer Smith.)

Cutrer became a well-known and respected attorney who accumulated part of his wealth through land ownership. One plantation he owned was Arcadia, about three miles north of Tutwiler. J.W. Cutrer died in 1932, and Blanche passed away in 1934. The Cutrer Mansion was rented out and then sold to the Catholic Church. The mansion became obsolete, but it was saved and renovated. Today, it is a designated historic property. (Rev. John Cutrer Smith.)

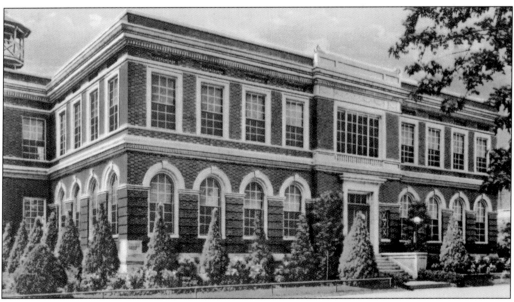

The stately city hall was constructed in 1917 and remodeled and enlarged in 1958. The building was maintained in immaculate condition, and the landscaping was picture-perfect. The city's pride showed in all aspects of the property. (PC.)

A later photograph of the viaduct on Issaquena Avenue shows the "gateway to the New World." In its day, the New World area drew wealthy white planters, successful African American entrepreneurs, home owners, and laborers. It was a melting pot of nationalities and religions, with a mix of everyone and everything that would build the city. On weekends, when everyone came to town, the blues pulsated through the air in juke joints and other establishments, relieving people of their everyday misery or escalating their joy. By 1900, the population of Coahoma County had jumped from 18,342 in 1890 to 26,293. The city showed slower growth, from a population of 781 in 1890 to 1,773 in 1900. These numbers went up as the city's business establishments and homes increased; by 1930, the people numbered 47,310. In 1900, W.C. Handy arrived by train to find S.L. "Stack" Mangham, cashier at Planters Bank. Stack had given him a job as conductor of the black Knights of Pythias Band. Stack, an African American, was employed by the bank until it ceased to exist.

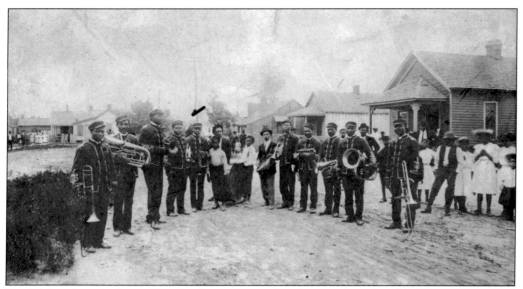

Stack Mangham (indicated by check mark) was the clarinet player for the Knights of Pythias Band. He was well respected by the local business community. With W.C. Handy as director, the band grew in reputation and income. Handy lived on Issaquena Avenue with his wife and three children from 1903 to 1909. A historic marker is located on the north side of Issaquena Avenue near the site of Hardy's home. (Mamie Louise Mangham Taylor/CPL.)

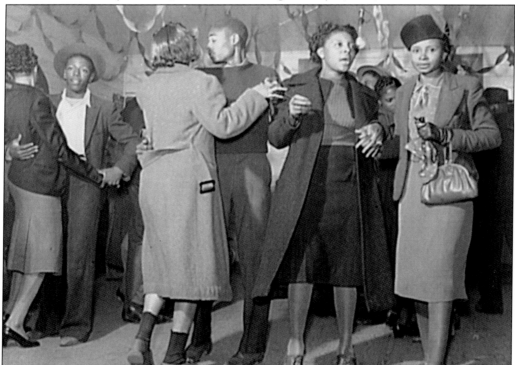

People put on their best clothes and frequented the New World establishments on Saturday nights. They danced to the old tunes they knew and the new sounds made from that music. (LC.)

Young and old alike enjoyed what the blues area had to offer. With so many people coming into the area, the matter of law enforcement arose. At one time, a midnight curfew was enforced. (LC.)

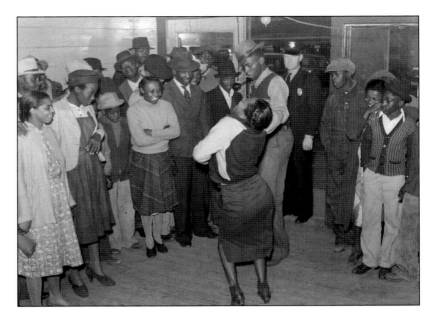

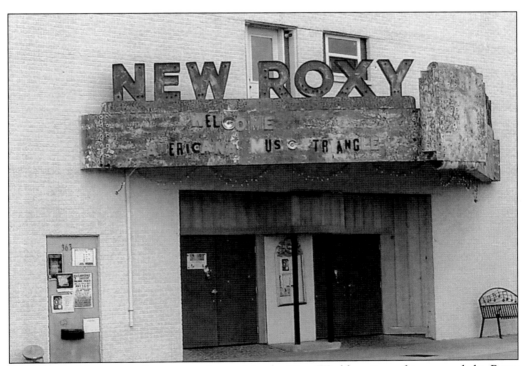

One block of Issaquena Avenue was located in the New World section of town, and the Roxy Theater, a motion-picture venue, was in the center of that block. A.N. Rossie and his wife, Saddie, owned the original Roxy in the 1940s. The New Roxy was an addition to the original, and both were in operation at the same time.

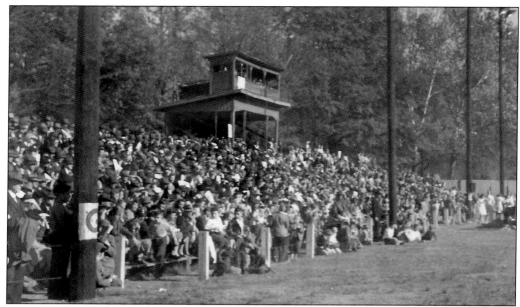

Clarksdale loved its ball teams. The Cotton States League existed from 1902 until 1913. It was reorganized in 1921 as the Mississippi State League. Professional baseball returned to one of the best baseball towns in 1934, when the Baton Rouge, Louisiana, franchise of the East Dixie League moved here. In 1935, a grandstand and bleachers were built, with lighting for night games. Fans turned out in large numbers.

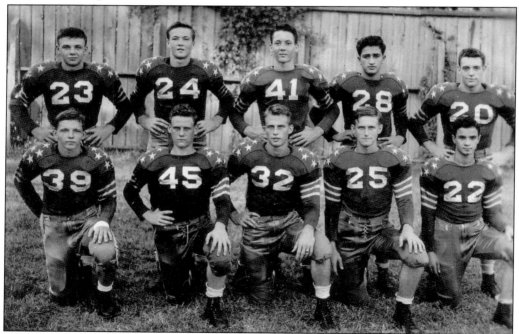

Members of the Clarksdale High School football team pose in 1946. Shown here are, from left to right, (first row) Claude Woodall, Frank Bailey, Billy Harlow, Graydon Flowers, and Victor Meena; (second row) Bobby Pitts, Leonard Kelly, James Kelly, George Gattas, and Charles Harris.

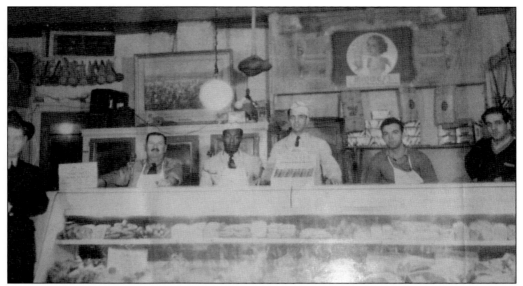

The Greek community began in Clarksdale when George Peters emigrated from Skopelos, Greece, to Pensacola, Florida. He heard that a grocery store was for sale in Clarksdale and in 1921 purchased the property. The store was renamed Peters & Chicouras. It was located on Fourth Street (now Martin Luther King Boulevard). Over time, Nick Peters, father of Manual Peters, and other Greeks settled here, as did those of other nationalities seeking to build a better life. (Manual Peters.)

The Grange was organized in the 1870s as a secret farmers' organization during Reconstruction. Members purchased land from John Clark on the north bank of the Sunflower River and erected a building, Grange Hall. The members met monthly, passed resolutions, exchanged farming ideas, discussed general business matters, and enjoyed social affairs after the meetings. The property is now the Grange Cemetery at the corner of Fourth and Sunflower Streets.

The Elks Home, on the northeast corner of Second Street and Yazoo Avenue, was a stately structure housing a reception hall, reading room, ladies' parlor, sun parlor, lodge room, pool room, grill room, secretary's office, and barbershop. Many prominent people in the area have been officers and members. (CC.)

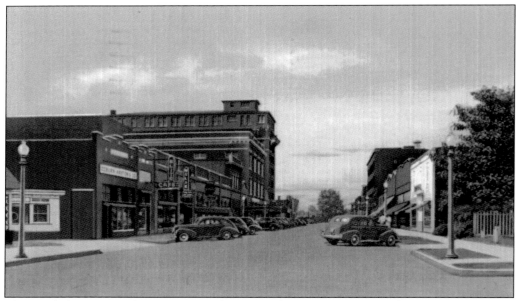

This south-facing view, from East Second Street and Yazoo Avenue, includes signage for Osborn Abston & Co., Elite Cafe, and Wilie Bros., Inc. The Coca-Cola sign indicates the location of the Peny-Savr Store. (PC.)

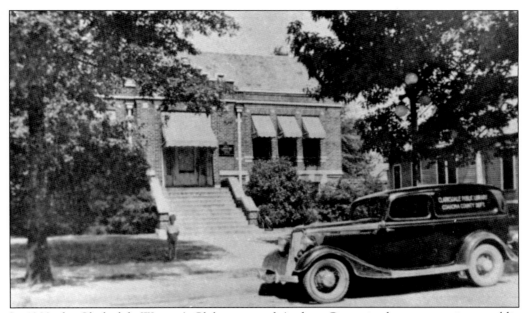

In 1909, the Clarksdale Woman's Club contacted Andrew Carnegie about sponsoring a public library in the city. On November 11, 1911, Clarksdale received a $10,000 grant from Carnegie, with the provision that the city purchase the land and sustain the library with annual funding. The city purchased a lot for that amount on the corner of First Street and Delta Avenue. On April 14, 1914, the doors of the library were opened.

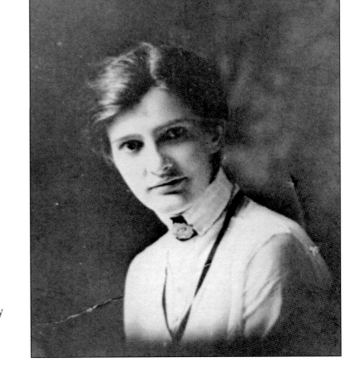

The first member of the library staff was Sarah Trimble, who served until 1915. Hoyland Lee Wilson (pictured) became the next director of the library and served for 33 years. The county board of supervisors began to share in financial support of the library in 1917. Rural library service was important, and several stations were opened in rural schools in the county.

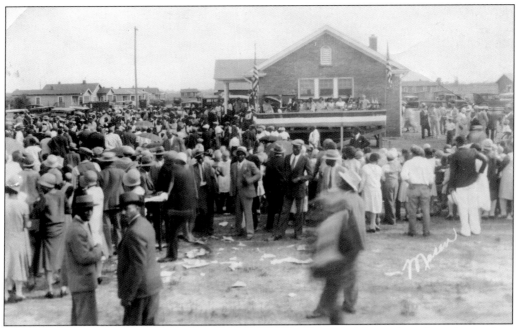

When citizens turned their concern for library facilities for the city's African Americans into action, a building lot was provided by the city's board of education in the Myrtle Hall neighborhood. The City of Clarksdale donated $2,100 toward the cost of the building, African American leaders in the community raised $1,100, and the Myrtle Hall branch of the Carnegie Public Library opened on May 4, 1930. A large crowd gathered for the dedication ceremony.

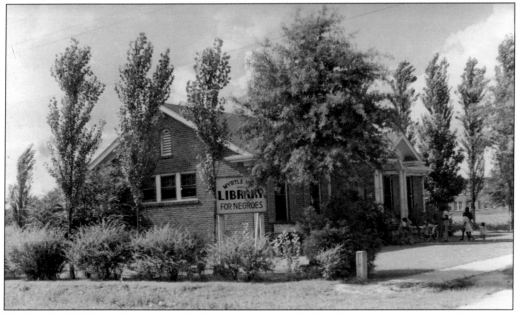

The Myrtle Hall branch was the only library in the state built with local tax money, and it became the envy of other cities throughout the state. The library was a prime example of Clarksdale's continued progress toward a better and more informed community.

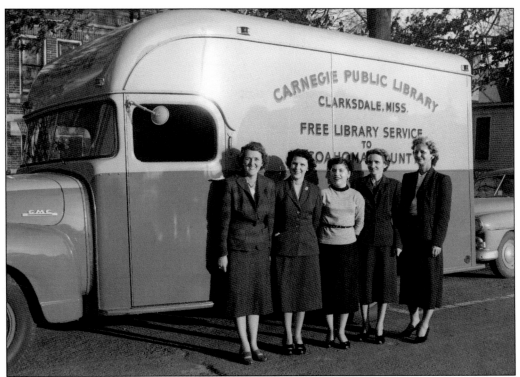

The Carnegie Library in Clarksdale has received many awards and additional funding in its years of operation. It was recognized for being one of the earliest libraries in the South to extend services into the county. The Rosenwald Fund enabled the library to greatly increase its book inventory. Anona Jenkins (far left) became the head librarian in 1948. In 1954, this library was named the best in the state.

In 1930, R.V. Wasson purchased the Oliver Bus Company from his uncle J.E. Oliver in Drew and moved it to Clarksdale. The Wasson Bus Line grew to include several Beck brand buses, which carried passengers to Memphis, Jackson, and other points across the state. Clarksdale schools chartered the buses, and they were an important mode of transportation during World War II. This franchise was sold to Greyhound Bus Lines in the early 1960s. (Debbie Miller.)

In the 1930s, Louis C. Koelling opened the Koelling Bottling Co. plant at 310 Tallahatchie Avenue, between Issaquena Avenue and the railroad tracks. He had sold his creamery in Nashville, Tennessee, to a company that would become Baskin Robbins. Koelling also opened a plant in Greenwood. (Susan K. Stempler.)

The Louis Koelling home was located in West Clarksdale on what became School Street. Koelling designed the house with hydraulic lifts underneath the structure, so it would not shift. His son Perry and his family owned the home in later years as it became surrounded by subdivision development. (Susan K. Stempler.)

Inside the Koelling Bottling Co. plant, an employee checks to make sure the bottles are clean before adding sugar and flavoring. The sterile environment included what was, at the time, up-to-date assembly-line equipment. (Susan K. Stempler.)

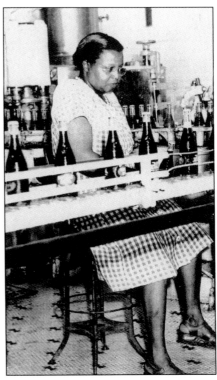

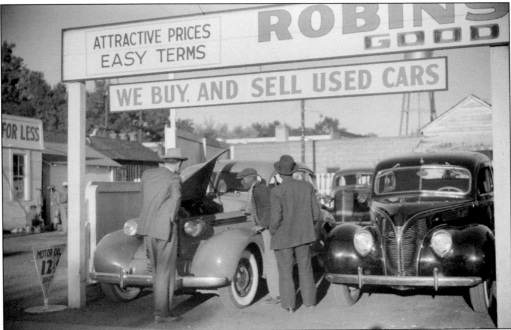

Each fall, after the crops were harvested, people had money in their pockets. Among the most important items on their lists was an automobile. Dealerships selling new and used cars were stocked and ready for this time of year. (LC.)

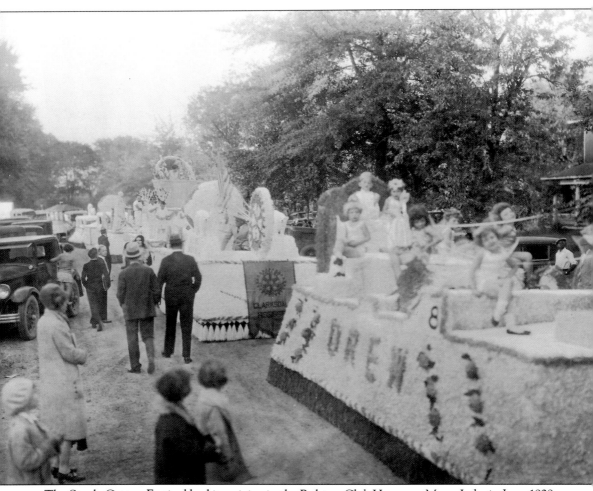

The Staple Cotton Festival had its origins in the Ralston Club House on Moon Lake in June 1929 at a regular meeting of the Clarksdale and Coahoma County Chamber of Commerce. The festival was proposed to be Delta-wide in participation to be held at the end of the cotton crop cycle in the fall. After all, Clarksdale was the "Golden Buckle on the Cotton Belt." When the festival was held in 1929, a record crop had been produced, and it was fitting that a celebration be held in the name of an industry that had brought about the tremendous progress of the Delta. E.W. Still is credited with the idea of this event, serving as chairman for seven years. Mrs. Robert S. Ralston played an important role as secretary for six years. In 1930, when it looked like there would be no second year's festival, Capt. Tom Gibson stepped forward and advanced the needed funds. This festival became the outstanding event in the entire Delta and gained national attention. (CC.)

Lovely Margaret Birdsong rides on the float for Co-op Auto Dealers of Clarksdale. Parades and floats had become more competitive through the years and began to appear professional in their presentation. The 1936 festival celebrated the 100th anniversary of the county, and a nationally known production firm was employed to stage extra features. (CC.)

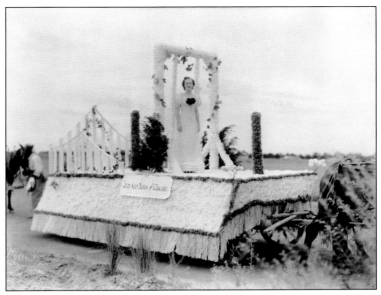

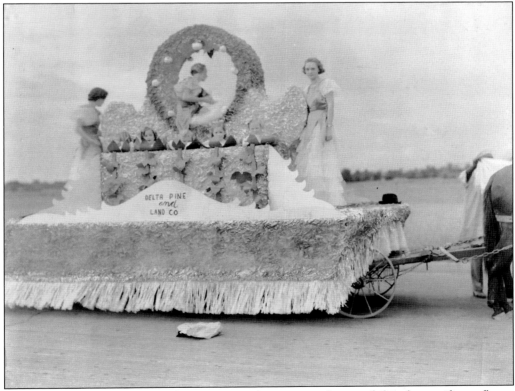

Companies across the Delta and important to the cotton industry exhibited magnificent floats. This one, provided by Delta Pine & Land Co., incorporates several children. The 13th annual festival was held in May 1941 to coincide with the celebration of DeSoto's discovery of the Mississippi River. It was a spectacular event lasting four days and included a play featuring most of the citizens of the county and Tutwiler. (CC.)

Very few authors are able to capture the mystique and culture of the Delta, although many try. Sometimes, an author attempts notoriety by publishing untruths that are not disputed and are unworthy of intelligent effort. Robert Rylee, however, was not such an author. Educated in the North, he was a "Southerner by preference and choice." He had ancestors in early Coahoma County who moved to Memphis, where he was born. It is apparent that Rylee was very familiar with the city and county, as two of his novels capture the essence of real-life characters who actually lived there during the period he wrote about. He was also very knowledgeable about the landscape and the society, gaiety, and anguish of these people. *St. George of Weldon*, his second novel, was published in 1937 and closely follows the sad story of the son of a prominent Clarksdale family. Lewis Gannett of the *New York Herald Tribune* wrote in regard to the novel, "Its chief distinction lies in its poetic sense of identity with the soil, of the rhythm of the season, of the languorous Mississippi land." (Robert Rylee.)

In Robert Rylee's first novel, *Deep Dark River*, published in 1935, a young lady practices law in Clarksville, Mississippi. The lawyer goes up against the establishment to represent an African American man arrested for murder in the early 1930s. Willie Yeates Rylee, sister of Robert Rylee, the author, is shown here. Willie, an attorney, boarded with the Walter Clark family on Court Street in Clarksdale in 1930 and actually had such a case in 1932. More witnesses were called by Rylee in this trial than anyone could ever remember. (Robert Rylee.)

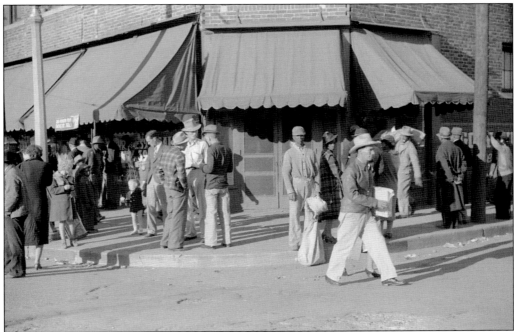

The price of cotton might fluctuate, the weather might not cooperate, and it took the same number of laborers to make a good crop as a poor one. Clarksdale was still the "Wonder City of the Delta," and business districts continued to flourish. (LC.)

The Clarksdale Hospital was a dream come true when it opened its doors to patients on September 17, 1923. This was an important asset to the city of Clarksdale, to Coahoma County, and to neighboring counties. The professional staff included 13 doctors in Clarksdale and 10 doctors in the county.

Simon Kooyman founded the first high school band in Mississippi at Bobo High School in the city. He organized the "Pioneer Band" in 1930. Because of his efforts, the Clarksdale High School band was given the title of Clarksdale's Ambassador of Goodwill. The band won more state championships than can be named here. Clarksdale was for many years one of the few schools in the South with an orchestra, which Kooyman organized.

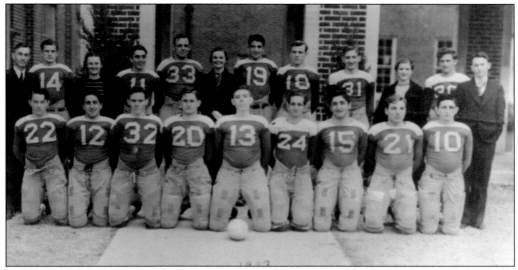

Members of the 1933 Delta championship football team of Clarksdale High School pose for a photograph. They are, from left to right (first row) Dotch Campbell, Zip Farris, Bernie Smith, Dudley Patterson, J.P Hill, Aubrey Rivers, Fitz Ferris, Joe Garst, and Robert Kincade; (second row) coach Dan Crumpton, Gordon Still, sponsor Katherine Parchman, Johnnie Campassi, Maurice Fletcher, Elizabeth Keeler, Joe Gattas, Alton Taylor, Wiley Critz, Kathleen Jones, Rigby Rogers, and manager Pete Williams. (Joe Garst/CPL.)

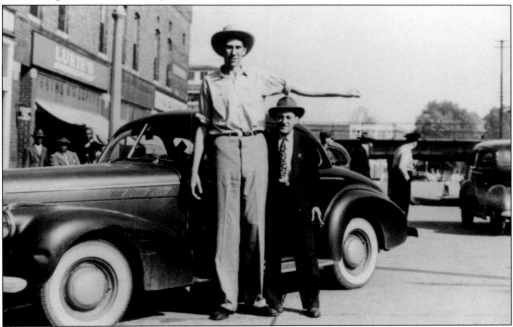

Max Palmer was a normal-sized boy until the age of 14, when he began to grow taller. He grew to be eight feet, six inches tall, and at one time he weighed 450 pounds. At his maximum height, he wore a size 20 shoe on the right foot and a 21 on his left. Palmer appeared in low-budget movies, including *Invaders from Mars* and *Killer Ape*. He became a wrestler and then a preacher. (Carlisle Jones/CPL.)

Born in 1885 in the Russian village of Radishkovitz, Abe Isaacson arrived in New York City at the age of 20. While staying with an uncle, he worked as a salesman, learning the English language. For the most part, factory jobs were available to immigrants, and he did not care for the city, so Isaacson bought a bicycle and tintype camera and traveled coast to coast as a freelance photographer. Traveling with the Ringling Bros. and Barnum & Bailey Circus, he visited Clarksdale and met Harry Kantor, a boyhood friend from Radishkovitz who had settled in Clarksdale. Isaacson met Eva Michelson, also from his Russian village, in Auburn, Maine, while employed with the circus, and he made a decision to marry her. In 1917, he bought a store on Sunflower Street and brought his bride to Clarksdale. There were 10 Jewish families in the city, making their living with small businesses or peddling in the countryside. His love of reading led Isaacson to open a secondhand bookstore until he retired at age 90. He wrote *From the Russian Ghetto to the Mississippi Delta*, the manuscript of which can be found in the Carnegie Public Library of Clarksdale.

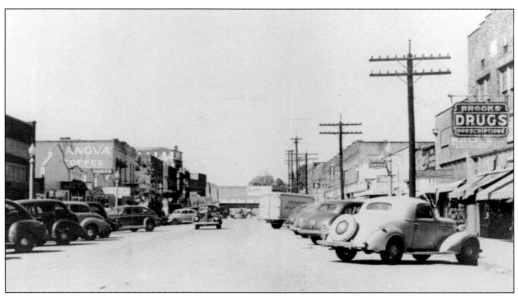

Clarksdale was noticed by regional and national publications for its explosion of growth and prosperity from the 1920s forward. It was labeled the richest agricultural city in the United States in proportion to its population. City and county leaders were progressive in their plans, knowing what was needed and how to implement ideas. By 1936, there were over 25 wholesale and 223 retail facilities, 19 white churches, 10 African American churches, and all the amenities of a modern city. Gone were the muddy streets, bad water, and outdated buildings. Modern Clarksdale was moving forward at a fast pace. Shown above is Issaquena Avenue, and the photograph below depicts Yazoo Avenue.

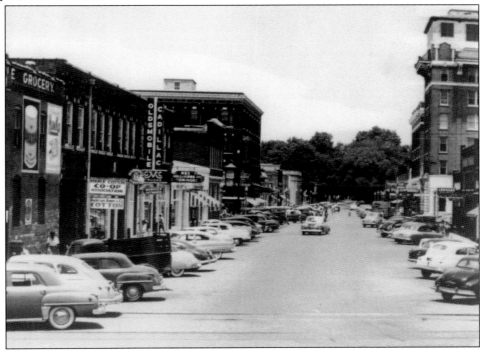

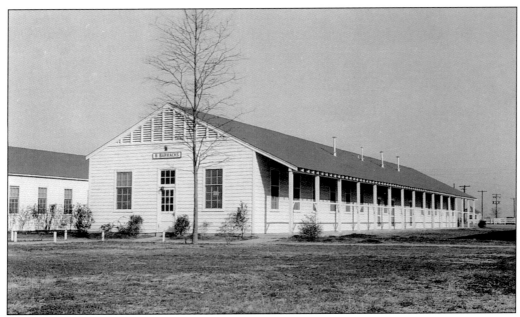

Fletcher Field, near Clarksdale, was opened on July 5, 1942, and used by the US Army Air Force as a basic flying training airfield. It was operated by the 2154th Air Base Unit, Contract Flying School (69th Army Air Force Flying Training Command), Clarksdale School of Aviation. Students flew Fairfield PT-23 and Boeing-Stearman PT-17 trainers. The United States prepared to enter World War II and expanded its number of flying squadrons by increasing the number of contract primary schools. The government supplied students with training aircraft, flying clothes, textbooks, and equipment. A detachment of the air corps was placed at each school to supervise training. The schools furnished instructors, training sites and facilities, aircraft maintenance, quarters, and mess halls. Schools received $1,170 for each graduate and $18 per flying hour for students eliminated from training.

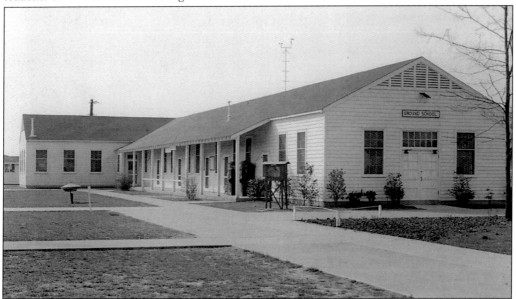

The first commandant was Maj. T.W. Bonner (at right), and he and the civilian flight instructors were determined to graduate the best-trained cadets. Local flight instructor Ed Young, remembering the PT-23 and the hundreds of cadets he taught to fly, once said, "We took them cold . . . they didn't know a stick from a prop." When Young retired, he had flown over 10,000 hours during his 40 years in aviation. Sonny Anderson and Dominic Correro were other aviation greats during the training at Fletcher Field. This was a time when people could not do enough for young men preparing for war, and Coahoma was no different. With donated funds, county residents built and maintained a recreation center and made their homes available for dinner and off-duty stays. When German prisoners of war were held there, they formed a band and played for dances in the center. There were many young ladies from Clarksdale for dance partners.

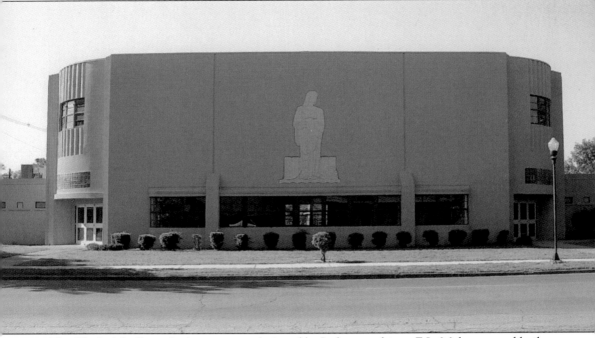

The Clarksdale Civic Auditorium was designed by Jackson architect E.L. Malvaney and built as a WPA project in 1939. The facility, erected in the Art Moderne style, has seating for 1,500. The walls are poured concrete, and the front facade includes a widely admired bas-relief. The building projects prosperity and progress. The two front entrances on each end of the building are on canted walls and have rounded corners with fluted columns. A band of glass blocks is above each of the entries. The building has accommodated every possible event imaginable. Elvis Presley's first "concert" here was in late 1954. He was reported to have said, "Thank all three of you for coming." Presley again appeared at the auditorium on January 12, 1955, and on March 10, 1955. Jerry Lee Lewis also performed there.

Thomas Edward Williams, formerly a project engineer with the highway department, and his wife, Voreen, came with their family to Clarksdale at the end of World War II, when the Tyson Theater was built. Thomas Williams owned this venue, the latest of the motion-picture theaters in Clarksdale. Williams also owned the Delta Theater on East Second Street (which later burned down), the Paramount on Yazoo Avenue, and the New Roxy on Issaquena Avenue. (Linda W. Porter.)

Thomas Williams (seen with wife Voreen) came from a family of theater owners who had locations in Grenada and Jackson. He was president of the Mississippi Theatre Owners' Association and led the fight against the unfair amusement tax of 12 to 13 percent paid by Mississippi moviegoers in the early 1950s, which was the highest in the nation. (Linda W. Porter.)

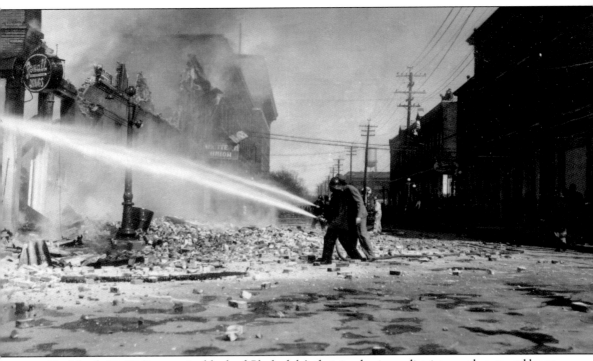

On March 16, 1947, an entire block of Clarksdale's thriving business district was threatened by an intense fire, which was spread by strong winds. Flames reportedly reached 40 feet high and were seen 10 miles away. Mayor John C. Newman sent out an appeal to neighboring towns, and fire equipment was sent in from Drew, Tunica, Marks, Tutwiler, Cleveland, Greenwood, and Shelby. The 67 guests of the 200-room Alcazar Hotel and its annex safely exited. The hotel annex, a two-story brick building erected in 1895 by Clarksdale, King & Anderson, was destroyed, as were the second and third floors of the main hotel building. Smoke and water badly damaged the rest of this building. King and Anderson Real Estate Co. owned the hotel property as well as the burned-out buildings occupied by Shankerman's Clothing Store, the Marian Shoppe, Luther Henderson Drug Store, Delta Optical Service Co., Western Union, Brown & Rosatti Barber Shop, Jewel Shop, Office Supply Co., and Ellis Drug Co. Businesses across the streets had some damage, but "Cotton row" was spared.

Riverside Park, seen here from the Second Street Bridge, was a beautiful, landscaped park on the banks of the Sunflower River. The American Legion Memorial Park, also on the river, had well-tended open spaces and gardens. A fireman from the nearby station cared for the animals in the park's zoo. (PC.)

Brothers Henry and J.W. Gotcher started their plant in a blacksmith shop in 1946. In 1951, they moved to Anderson Boulevard into a huge, modern plant. The Gotcher Engineering & Manufacturing Co. turned out farm machinery suited for conditions in the South. The company's first development was the flame cultivator, which burned weeds and grass under cotton but did not harm the plant. The firm pioneered the use of anhydrous ammonia as nitrogen fertilizer and built the first applicator equipment. (CC.)

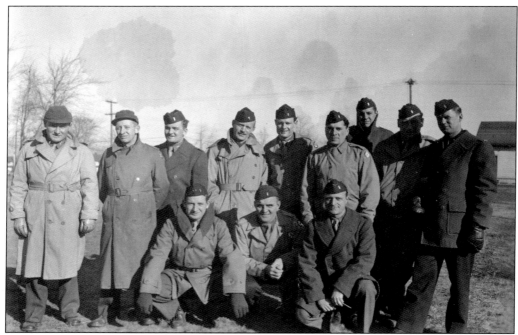

The majority of the German prisoners held at Fletcher Field during World War II were from Rommel's Afrika Korps. Other prisoners, Italian and German, were held in a stockade at the old baseball field on Fourth Street. Prisoners were sent out to farms for work, and the county agent would make arrangements with farmers for the prisoners to chop and pick cotton. The farmers paid for their services. (Jean Duff.)

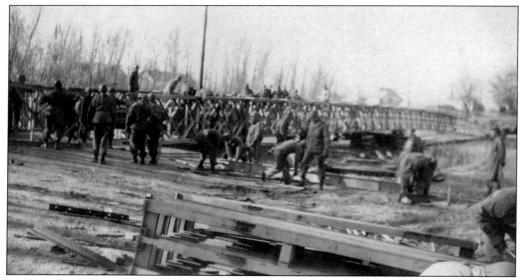

In 1942, the German prisoners built a swinging bridge across the Huspuckena River. They also built a bar for the commanding officer, Lawrence R. Stokes, with two removable trays using B-52 windshields for the bottom of the trays. On the bottom of a carving given to Stokes was written: "USA 1946 POW MAIER." The men respected military laws and rules and caused no problems. (Jean Duff.)

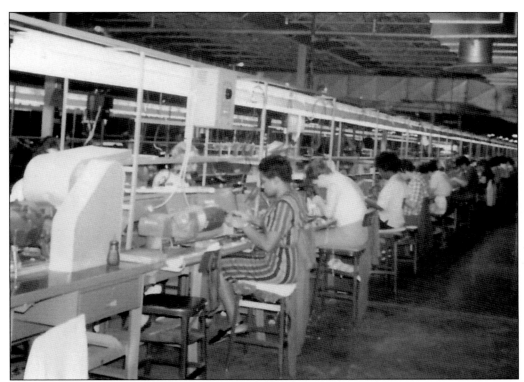

Leading citizens had always fought the coming of industry into Clarksdale, afraid that its rise would come at the expense of farm labor. With the mechanization of farming came the realization that jobs were necessary, and the city began to promote Clarksdale as an ideal place for industries. In 1951, the Strutwear Hosiery Mill built a factory and hired many women, who before had little opportunity for employment with good wages. (CC.)

Richard "Dick" Rollins and his wife, Marie, were very community-minded citizens. Rollins, owner of Peny-Savr grocery store and later the Village Grocery at the corner of Anderson Boulevard and Lynn Street, met the needs of his customers with good service. Customers called in their list of needed goods, and the items were packaged by store employees and made ready to be picked up. Marie, the organist for the Clarksdale Baptist Church, had many long years of association there. (CC.)

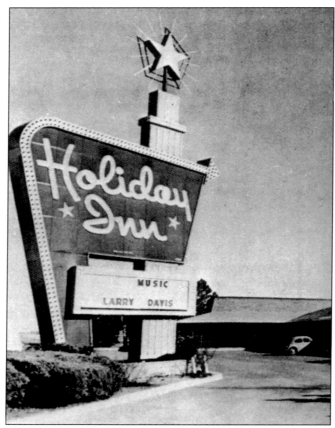

Traveling south on Highway 61 into Clarksdale, a traveler was greeted by the recognizable sign shown above. After Holiday Inns were built in Memphis, Kimmons Wilson partnered with Wallace Johnson to franchise the concept developed by Wilson. In 1954, the first franchised Holiday Inn opened in Clarksdale. The city had the oldest Holiday Inn location in existence when the last of the Memphis locations were sold. W.L. Holcomb, Clarksdale real-estate developer, bought the first franchise for an initial fee of $500 and 5¢ per occupied room per night. Judging from the check shown below, the fee may have been paid in installments. In the early days, US 61 was the main route between Memphis and New Orleans. The Holiday Inn was a success from its beginning and needed an expansion of 32 rooms, for a total of 100 rooms. (Both, CC/*Clarksdale Press Register*.)

COAHOMA COUNTY BANK & TRUST CO.

CLARKSDALE, MISS. _____ 8-12 19 54 No. 161

PAY TO THE
ORDER OF _____ HOLIDAY INNS OF AMERICA, INC. _____ $ 115.60

* * * 115 60

DOLLARS

FOR Franchise fee and national advertising _____ HOLCOMB MOTELS, INC.
Holiday Inn

By _____

KNOW YOUR ENDORSER

As a boy, Alfred H. "Brick" Gotcher lived near St. George's rectory, where young Tom "Tennessee" Williams was living with his grandparents, the Dakins. Gotcher did not like Williams, calling him a sissy, and they would often scuffle, with Tom crying all the way back home. Williams got his revenge years later, naming the unsavory character Brick in *Cat on a Hot Tin Roof* after Gotcher. In World War II, Gotcher served as an Army captain and was awarded a Silver Star. He was seriously wounded in service and spent several years in veterans' hospitals. He became sheriff of Coahoma County in 1952. In 1954, Sheriff Gotcher and another officer went into a cotton compress building, pursuing a man who had killed one person and wounded another. The sheriff opened a door, and the man started firing, mortally wounding Gotcher. As was the custom, Brick's wife, Miriam M. Gotcher, fulfilled his term as sheriff. (Gayle Gotcher.)

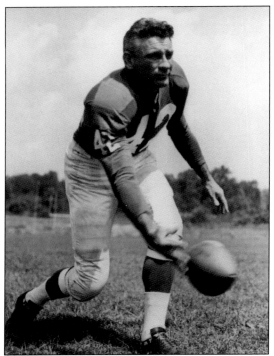

Charlie Conerly was a hometown hero, playing football for Clarksdale High School and then Ole Miss in college. He retired as quarterback for the New York Giants in 1961 at age 40. Conerly was named an All-American and was the nation's leading passer at Ole Miss. In 1947, he participated in a 43-13 win over Tennessee; it was the school's first victory over the Vols and made the Rebels the Southeastern Conference champion for first-year coach Johnny Vaught. In World War II, Conerly was a much-decorated Marine. For the Giants, he changed the team's record books and became known as one of the greatest quarterbacks professional football has ever produced. "Chunkin' Charley" was "discovered" by an advertising group, which turned his rugged good looks into part of the most successful cigarette advertising campaign in history. He appeared smoking in a tuxedo and as a cowboy on the range. (Both, Perian C. Conerly.)

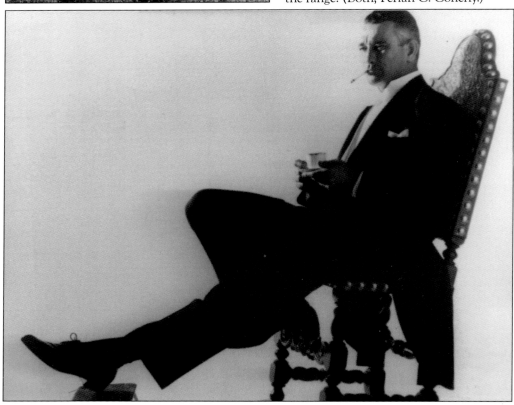

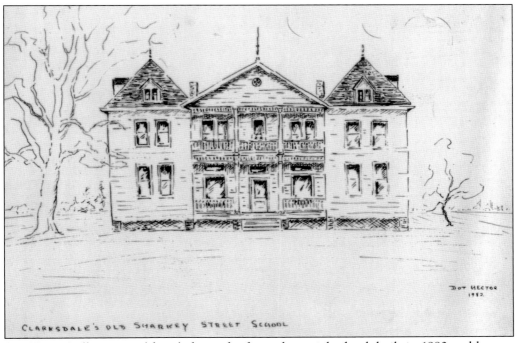

CLARKSDALE'S OLD SHARKEY STREET SCHOOL

Dot Hector's illustration (above) shows the first substantial school, built in 1880 and known as the Sharkey Street School. Classes were previously held in various locations and homes. Clarksdale's growth called for a comprehensive school system. By 1905, a municipal school district was established, and the board began a search for a school superintendent. Harvey B. Heidelberg became superintendent, and Clarksdale would have one of the best school systems in Mississippi. Heidelberg was appalled by the school facilities for both white and black students, and a solution was planned. Public School No. 1 (below) was built on West Second Street and Riverside Avenue, and Public School No. 2 was erected on Sunflower Avenue for black students. A few years later, Clarksdale High School was ranked among the best schools in the South. No examination for admittance was required for colleges in the state and many out of state. (Above, Dot Hector/CPL; below, CPL.)

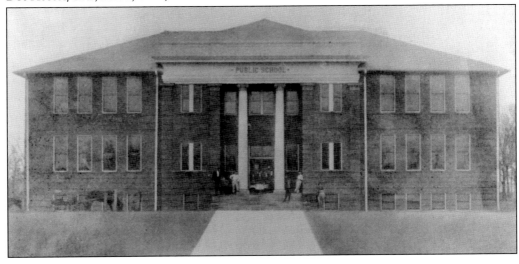

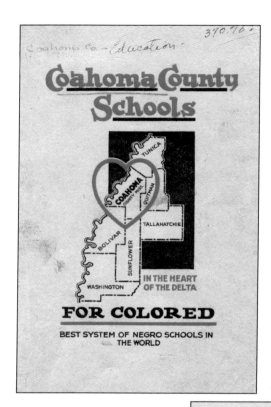

The material on this page, offensive to the modern reader, nevertheless indicates the importance placed on education for all citizens of Coahoma County in 1924. P.F. Williams conceived and proposed the organization of a school system for all African American children, and the board of supervisors adopted the proposal, to be financed by the citizens with no state or federal assistance. Nowhere in the world had such a system been proposed and realized. This may have been a way to lure more African Americans to the county, but the essential purpose of the action was to provide education for all children, wherever they lived in the county. The date of the booklet at left is not known, although the Agricultural High School and its 14 buildings had been completed. In addition, five junior agricultural schools had been built. Within four years, all schools would be operational.

THE
COAHOMA COUNTY
SCHOOL SYSTEM FOR COLORED

COAHOMA COUNTY HAS THE DISTINCTION OF PRO-
MOTING THE FIRST REAL SCHOOL SYSTEM FOR
COLORED CHILDREN IN THE UNITED STATES.

WHAT IS THIS SYSTEM?

Seventy Primary Schools
Sixteen Junior Agricultural Schools
One Agricultur.l High and Industrial School

LOCATIONS

Each school so located that every colored boy and girl in the county may have an opportunity of securing primary, grammar school and high school education.

BUILDINGS

How much of this system has been completed? The Agricultural High School, with its fourteen buildings—five junior agricultural schools, one in each Supervisor's District. All of these buildings are new, modern and well-equipped. Our plan calls for a four-year building program—at the end of which time, new buildings will have been erected in every section of Coahoma County. Through the untiring efforts of the County Superintendent and the generosity of the Board of Trustees, two dormitories have been completed during the summer. Have room for twice as many as last year.

All schools built and maintained by the county. The teachers are the very best that can be had.

In order to educate their children, residents of Chinese descent in the Delta had to form their own schools, with the aid of the Baptist church. When the Lula school closed, Henry Jue, with the support of Clarksdale Baptist Church and 88 citizens, petitioned the school board in Clarksdale for admission of his seven-year-old daughter, May (Magen), to a white school. This petition was denied, but later in 1941 May was admitted into the white public school.

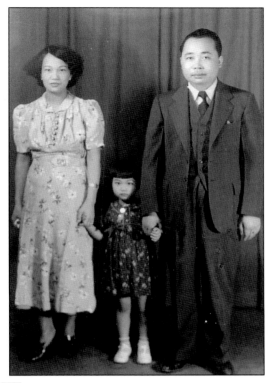

After the establishment of the historically black Coahoma Agricultural High School in 1924, a college curriculum was added in 1949, and the campus became Coahoma Junior College and Agricultural High School. This was the first African American junior college in the state. Dr. McKinley Martin (pictured) was the college's third president.

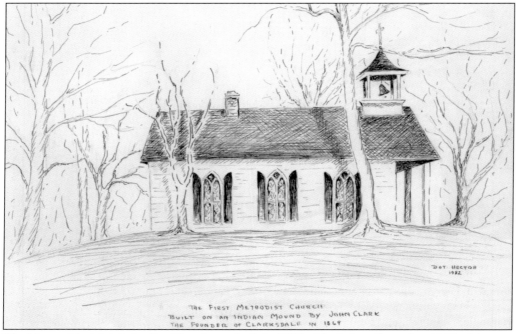

The Mount Moriah Methodist Church was built in 1869 with timbers from the old Clark house. It stood on a large Indian mound on the banks of the Sunflower River between the railroad and Third Street. About 1905, the church was moved to a lot on Yazoo Avenue and was used by an African American congregation. (Dot Hector/CPL.)

EPISCOPAL CHURCH, CLARKSDALE, MISS.

In 1892, the first Episcopal services were held in Clarksdale in a little whitewashed cabin. On that same lot in 1904, the present St. George's Episcopal Church was built. Rev. Alfred Todhunter was serving the parish at this time. (PC.)

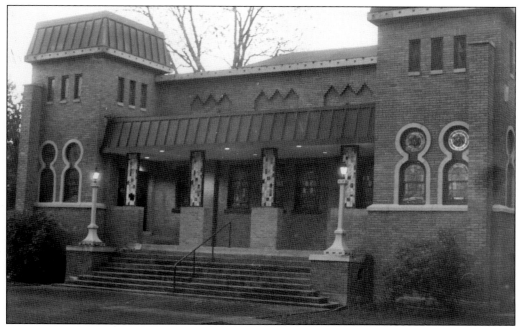

Temple Beth Israel, the second synagogue in the city, was located at 402 Catalpa Street. The first synagogue was located at 69 Delta Avenue. The Beth Israel Cemetery on Friars Point Road was established in 1919. In 1876, there was a small Jewish settlement here, and most of its members were of German descent. In the 1880s and 1890s, several Jewish families arrived from the Midwest, New York, and Lithuania.

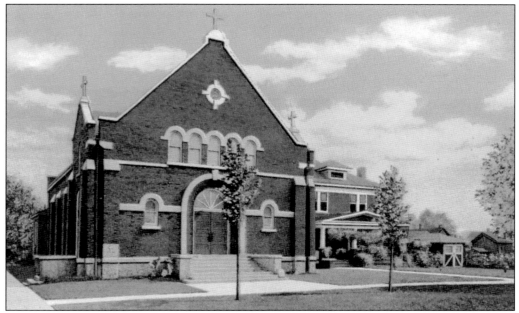

A frame building on Issaquena Avenue served as the church and rectory for St. Elizabeth Catholic Church after the parish was organized by Father O'Loan in 1891. In 1905, Fr. Peter Keenum came to Clarksdale. He erected the new church and rectory (pictured) on Fairland Avenue in 1913. (PC.)

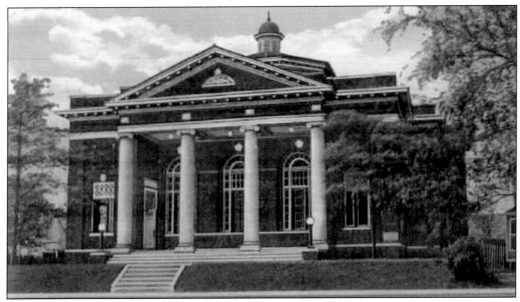

Clarksdale Baptist Church was organized by eight members in 1898. This small group purchased a lot and in six years completed their church. It stood where the Woman's Club is now located, on the corner of First and Sharkey Streets. Rev. A.L. O'Briant was the first pastor. In 1917, the church burned down. Services were then held in Eliza Clark School, with revivals in the courthouse. The congregation moved into its new church (pictured) in 1920.

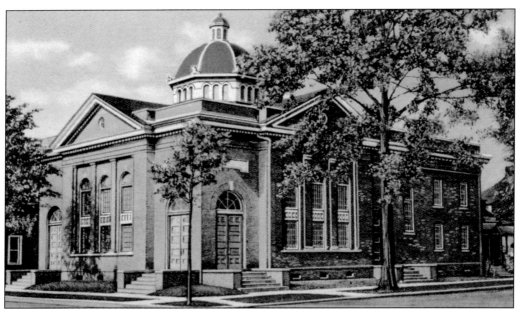

The First Presbyterian Church was organized in 1891 by Rev. T.W. Raymond, DD, and the first building was erected in 1893. After nine part-time pastors had served, Dr. Raymond served from 1910 to 1917, resigning after this new building was completed. (PC.)

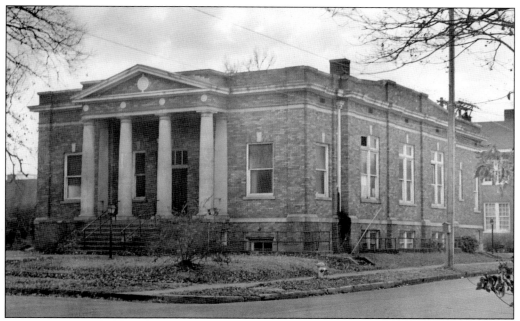

In 1915, five women met to plan for a Christian church in Clarksdale. After organizing a Ladies Aid Society, their numbers grew, and the courthouse became their meeting place. Dr. J.J. Castleberry of Kentucky organized the church, with 40 members, and it became known as the First Christian Church. It was located at the corner of LeFlore Avenue and First Street.

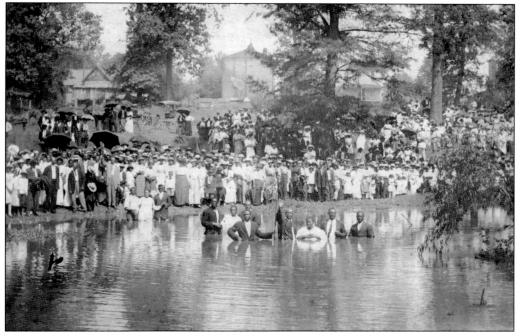

Most churches in 1918 were not equipped for baptismal services in the buildings, so waterways were utilized. This service may have included a number of congregations and was held at the Sunflower River in Clarksdale.

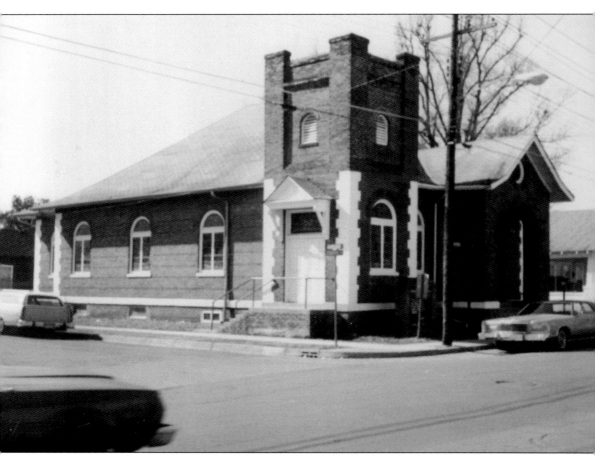

St. James Temple Church of God in Christ was located on Paul Edwards Street. In 1947, it moved to Fourth Street. Clarksdale's history contains amazing stories, and one starts with a young man from Clarksdale, Louis Henry Ford, born on May 23, 1914. He accepted Christ when he was very young and answered a call to ministry while a student at Saints College in Lexington, Mississippi. Ford was ordained in 1933 and at age 20 became one of youngest pastors of his denomination, founding St. Paul Church of God in Christ in Chicago in 1935. Having lived in poverty, he addressed the problems he saw around him through his church. Ford's impressive accomplishments in this area brought him many accolades. He found that working with government entities, rather than protesting, made it possible to help the less fortunate. He counseled with mayors of Chicago and Pres. Bill Clinton. When he presented the eulogy for Emmett Till, his eloquent preaching raised his popularity nationwide and throughout the entire Church of God membership. After long and dedicated service, he was elected presiding bishop over the world Church of God in Christ Church. This was an extraordinary honor, as the denomination had over six million members in 59 countries at that time.

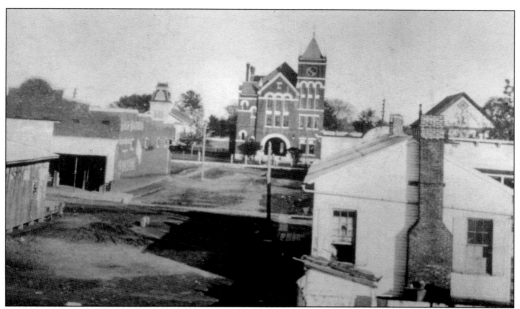

Friars Point is the only true river town left in Mississippi that water has not taken. Located near the famous Yazoo Pass, it was a major staging point for Union troops. During that period, the Friars Point United Methodist Church was burned by the troops after they attended services. This church was made of logs; the third church on this site was built in 1916. The town was shelled from the river daily without warning. Soldiers stormed through the town, stealing food and tearing down houses and buildings for the lumber. All of the able-bodied men were away at war, so residents were at the mercy of Yankee troops—and no mercy was given. Devastated by war, without a railroad, and with river traffic diminishing, Friars Point lost its standing in the county.

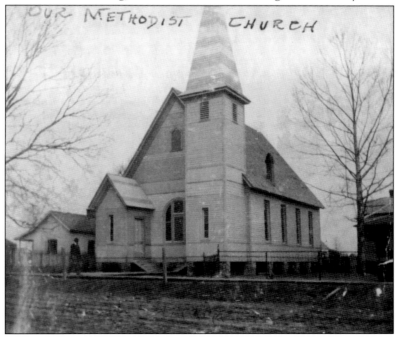

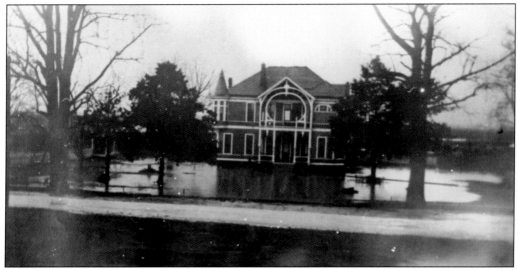

Riverview, the James D. Robinson residence, seems to be standing in the river in this rainy-season photograph dated 1916. The house, a showplace in its day, was located less than a mile from Friars Point's business district. This home, along with several other big residences on River Street, were moved when the new levee was built.

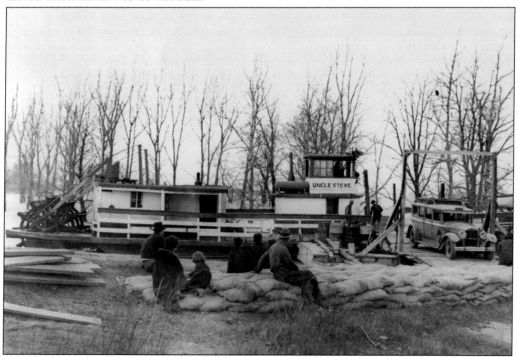

Transporting people and automobiles across the treacherous river was handled by ferryboats steered by seasoned pilots. One pilot, Floyd Jenkins, would later be without a job when the Helena-Coahoma County Bridge was built. His son Harold, later known as Conway Twitty, bought the *Belle of Chester*, which his father had piloted. The singer moved it to Moon Lake, adjacent to his nightclub, and his father operated it as an excursion boat.

Conway Twitty was born in Friars Point in 1933 in the house beside which he and Barbara Morris are seen standing. His home, off Sheriff Ridge Road, was later razed. Twitty hoped to play professional baseball but lost his chance when he was drafted into the US Army. He turned to music, initially playing rock, then country. He has become endeared to country music fans everywhere. Twitty had 55 no. 1 Billboard hits, more than anyone else at the time. (Barbara Morris.)

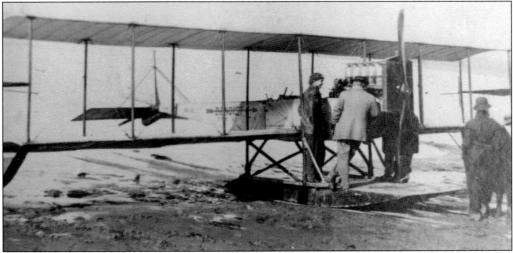

Planes often landed around Friars Point, some on the water and some on the levee. This is not Charles Lindbergh's plane, although he did land just north of Friars Point. He recounted his visit in his book *We* and wrote of visiting a haunted house, but he experienced no paranormal activity—evidently, a disappointment. (MMP.)

Lula was once home to some very interesting people. Dr. Nemo Yeates, a veteran Delta doctor, could have written a book on delivering babies on both sides of the river. Carl D. "Doc" Kirby, a former partner in the KBH Corporation, did write a book, *Latitud Cero*, about his farming and mining exploits in South America. Rex Armistead, an international private detective, was involved in the Arkansas Project investigating Pres. Bill Clinton. (Robert Tomb.)

Clyde Graham (second from right), from Coahoma, Mississippi, took first place in Mississippi's first State Duck Calling Contest in 1948 and also won the skeet shoot held on the same day at the Clarksdale Gun Club, with a perfect score of 200 without a miss. Billy Kincade (second from left) came in second place; Buddy Whitaker (far left) was third. Johnny Campassi (far right) presented the first-place trophy to Graham. (Floyd Graham.)

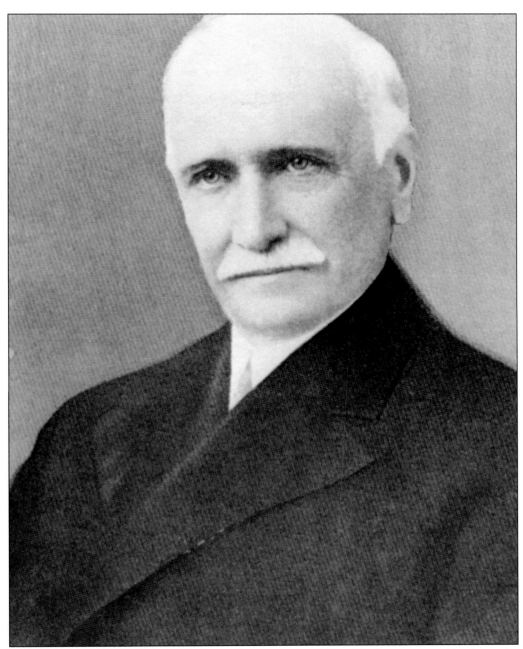

Col. David Moor Russell bought land near Jonestown in 1865 and built a two-room log house he called Matagorda. It was remodeled several times by Russell and his wife, Mary Bliss Russell, and became a 22-room mansion, a center of elaborate social events. The Russells had no children, but adopted John Bell Hood Jr., the son of Russell's commanding officer, Gen. John Bell Hood. The general had died of yellow fever in 1879, six days after the death of his wife, Anna. Left were 10 destitute orphans, all very young, including three sets of twin girls. General Hood's staff officers agreed to adopt one child each. Hood Jr. came to Matagorda and later served in the Spanish-American War. (*Mid-South and Its Builders.*)

At the age of 70, Col. David Moor Russell became ill and sought treatment in Boston. He survived, but Mary, his wife, died while there. He then married a young nurse, Margaret T. McManus, who was 40 years younger and had cared for him while in Boston. His adopted son, John Bell Hood Jr., was about the same age as his stepmother. The colonel died in 1918; soon after, Margaret married her adopted son. Their wealth provided for elaborate parties and world travel, during which extravagant treasures were purchased and displayed at the family home, Matagorda, in stylized settings, arranged by country of origin. The Hoods had two sons, John Bell Hood III, who died accidentally while young, and John R. Hood, called Robin Hood. John R. legally changed his name to that of his deceased brother. Shown here are Margaret (Maggie) and John Bell Hood Jr. with their children Robin (left) and John Bell Hood III. The couple sold the land to pay for their travels. They became destitute, and Margaret developed dementia. She lived out her life in the Clarksdale Hospital. Robin died in a mental institution. (Floyd Graham.)

Maj. Lamar Fontaine came to Lyon in 1893 through an association with the railroad. He tells in his *Life and Lectures* about the building of Ridgeway, his grandfather's home in Pontotoc County, Mississippi. His grandfather was Col. Patrick Henry Fontaine, first grandson of the Virginia patriot Patrick Henry. Lamar was born in a tent in Texas in 1829, lived with Native Americans for four years, and traveled to Japan, India, China, Persia, Arabia, Egypt, and Syria, fighting with armies in or against those countries. He served with the Mississippi Infantry and with the Virginia Cavalry, where he was known as the deadliest sharpshooter. Fontaine was named to the Confederate Roll of Honor for service in Vicksburg. Taken prisoner in 1864, he became one of the noted "Immortal Six Hundred," a group of 520 captured officers used as human shields by the Union to try to silence the Confederate guns at Fort Sumter. He wrote *The Prison Life of Major Lamar Fontaine One of the Immortal Six Hundred* about the inhumane treatment of those soldiers. He was a civil engineer, doctor of philosophy, soldier of fortune, and poet.

Elizabeth Lee Hazen was born in 1885 in Rich, Mississippi, to William Edgar and Maggie Harper Hazen. Her parents died when she was four, and she was adopted by an aunt and uncle. Hazen attended Mississippi University for Women (then Mississippi Industrial Institute and College) and taught biology and high school physics in Jackson, Mississippi. After teaching, Hazen completed her doctorate of philosophy in microbiology at Columbia University in 1927, one of the school's first female doctoral students. She worked for the State Department of Public Health in New York and in 1948 began working with Rachel Fuller Brown, a biochemist, to find an effective antifungal agent. Hazen found a promising substance, and in 1950 she and Brown developed nystatin, the first fungicide safe for humans. The drug cured a number of disfiguring and disabling fungal infections of the mouth, skin, throat, and intestinal tract. From the sales of nystatin, Hazen and Brown donated over $13 million in royalties for science and advancing women in science. (Mississippi University for Women.)

On a winding road off the Bobo-Rena Lara Road is Peter's Rock Metropolitan Baptist Church, now in a state of decay. Families from three plantations, Kline Planting Company, Stribling Plantation, and the Mark Ham Place, once attended the church. Families living on both sides of Black Bayou attended. There is a large cemetery adjacent to the building with few markers and many depressions, indicating grave sites.

Judith Eveline Gary, born in 1857, daughter of William West Gary, described her first visit to Sunflower Landing, near where her grandfather Allen W. Gary owned a plantation, the Indian Village. The steamer *Robert E. Lee* stopped in the current, and the Garys boarded a skiff and rowed to a store. The first floor was flooded, and they entered the second floor. Another skiff rowed seven miles to the plantation; meanwhile, they saw nothing but water. After recovering from malaria, the Garys went back to Carroll County. (Flowers family.)

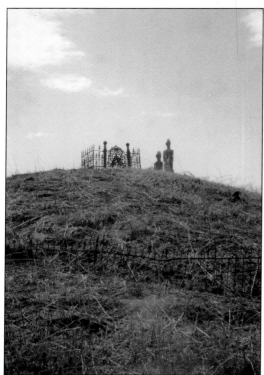

Indian mounds in Coahoma County were utilized for cemeteries due to frequent floods. The Legg Family Cemetery is located in Mattson; from atop the mound, one can see across the land owned by Pleasant Crawford Legg, who died on March 18, 1893. A marker indicates that the cemetery was established by trust deed on December 30, 1889, by Annie E. Legg, wife of P.C. Legg, for the burial of their relatives and descendants.

In 1934, the children of Mattson and Dublin celebrated the birthday of George Washington and Graydon Flowers Jr. They are standing on the steps of the Tutwiler Woman's Club. The identified children in the first row are Joann Jennings (second from left), Graydon Flowers Jr. as "George Washington" (third from left), and Eva Ann Dickens as "Martha Washington" (second from right). Peggy Lawler is at far left in the second row, and Medora Lawler is at far left in the third row. (Mary Helen Flowers collection.)

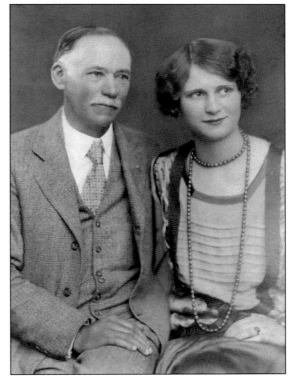

The United Methodist Church in Mattson (above) replaced an older church building. The town was named in 1897 for the family who owned a large sawmill there. While the first highway in Coahoma County was being constructed from Clarksdale to near Tutwiler, residents furnished room and board for the contractors, engineers, and workmen. Charles Clark Sr. stated that the old Indian trail "Charley's Trace" crossed Hopson Bayou on the plantation of R.B. Eggleston. Richard Baugh Eggleston graduated from the University of Mississippi in 1890 and attended Eastman Business School in New York. He was the depot agent, postmaster, and bookkeeper and managed the store for Col. John Stovall. He and Dr. McElroy, later the world-famous malarial expert, lived in the back of the store. Eggleston married R.N. McWilliams's sister, Willie McWilliams, and they came to Mattson in 1909. Eggleston and their daughter, Mary Helen, are shown at right. (Both, Mary Helen Flowers collection.)

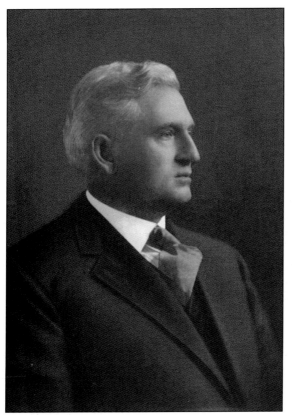

John Wilson Lawler was born in Coahoma County in 1875. His family moved to Florida when he was young, and he continued his education at Emory College in Georgia. He went to Alabama and farmed for one year, but the pull of the fertile Delta was strong, and he returned to manage the J.R. Coates Plantation. In 1906, he married Medora Hilliard, daughter of Capt. H.E. Hilliard, and became a merchant in Dublin. He also began to lease land; in 1913, he was working 2,400 acres. After four years of leasing, he began to use his earnings to purchase land. Lawler accumulated 4,300 acres, including the town of Dublin east of the railroad, where his residence (below) was located. (At left, *Mid-South and its Builders*; below, Billy Talbot.)

Dublin Methodist Church was built in 1928. Before that, the Cherry Hill Church, just south of Dublin, served the community down to Tutwiler as a place of worship from 1873. Beginning about 1857 or 1858, Cherry Hill was a burial place because of its higher elevation. Benjamin W, Lawler donated three acres of land for the cemetery and log church, called the "Mother church of the Delta" by Methodists.

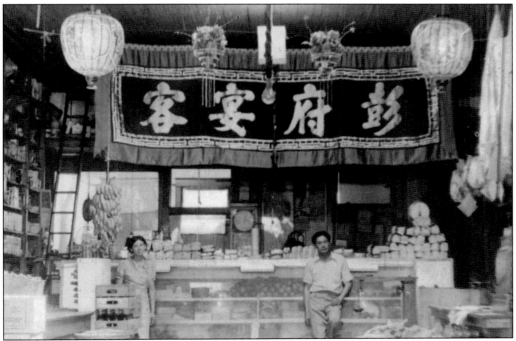

King Pang Chow (left) and her brother Linn Yee Pang are shown in the Pang family grocery in Dublin in the 1930s. Their father, Jone Sam Pang, was one of the early settlers of Quitman County. He grew Chinese vegetables and shipped them to Chicago and owned grocery stores in Marks and Dublin. Sally Chow's mother, King, was the first Chinese student to attend college in Mississippi. (Sally Chow.)

William Hodge Cagle Jr. was born at Cagles Crossing in 1901 to William Hodge Cagle Sr. and Malissa Almetta Carroll. He told the story about his Cagle uncles, Confederate soldiers who escaped from a Union prison and came to the swamps to avoid recapture. He and his wife, Hazel (at left), and their family of farmers, teachers, and church members helped build the community. In 1938, the entire community contributed to the building of the Cagles Crossing Methodist Church–Union Chapel Baptist Church (below). The Baptists and Methodists met on alternating Sundays. A simple marker stands in the Cherry Hill Cemetery for William Cagle, Confederate veteran. It is one of the earliest markers. Murl S. Spurry, from Kansas, married Hodge's sister Mary. He was on a cattle drive through the county when he met her, and they remained here throughout their lives. (At left, Cagle family; below, author's collection.)

Four

AGRICULTURE

Timber was cut, the dense forests were opened up, and the extremely rich, alluvial soil was exposed, ready and waiting for farmers to utilize its assets. Farmers tried crops grown in areas that they had left, and the Delta showed them how unfit those crops were in the hot, humid climate. Slave labor was utilized by some, and their numbers would increase as ownership of larger tracts led to expanded production.

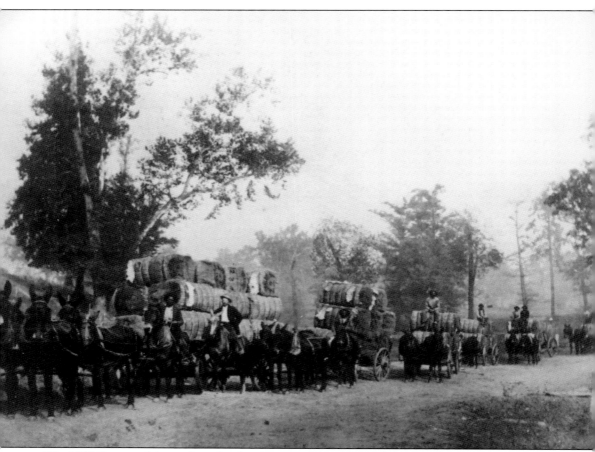

The 1850 Census of Agriculture for the county indicated large plantings of corn, sweet potatoes, and some rice. The 1860 Census of Agriculture showed ownership of larger tracts and more land being cleared. There was a significant increase in bales of cotton. This may have been due to a Mexican variety of cotton introduced into the country by Walter Burling of Natchez and subsequent improvement of varieties by William Dunbar and Dr. Rush Nutt in the Natchez area. The Upland cotton that was developed was white, its fiber was longer, it was easier to work with, and it became much in demand. Soon, cotton was firmly established as the principal cash crop in Mississippi, and every available acre was planted in this crop for years. Labor was plentiful, and the land was productive; however, planters began to realize the need for better cotton varieties, improved cultivation methods, better tools, and scientific research. They needed weed and grass control; the boll weevil infestation had ruined many farmers.

After the noon rest on the King and Anderson Plantation yard, where young men watched the mules, the men took the mules and cultivators out to finish the day's work. Mules were better suited for this work than horses and oxen, used in the past. Mule auctions were held across the Delta, where farmers could purchase the animals and where they could communicate with other farmers about production, machinery, and other subjects affecting their livelihood. Being a valuable commodity, crop loans were often dependent on the number of mules on a place. Farm machinery had begun to evolve at this point and would decrease the time and labor necessary to work the land. (Both, LC.)

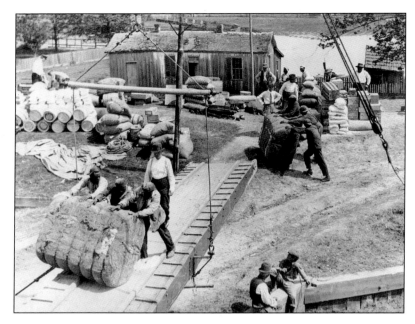

Bales of cotton are being loaded onto the steamer *Kate Adams* in 1912 in Friars Point. Farmers faced an arduous task just transporting the bales to this location, as there were few roads. And, at times, floods and rainfall made the roads nearly impassible. (MMP.)

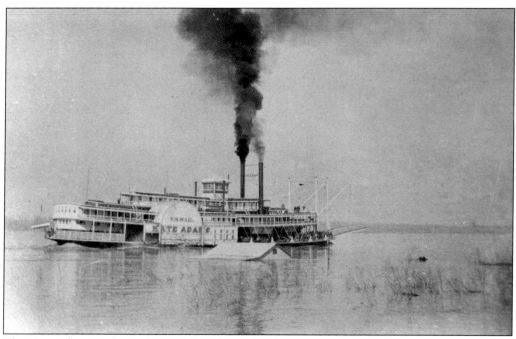

The *Kate Adams* made regular runs from Memphis downriver to Friars Point to deliver and reload mail, commodities, and passengers. These boats were essential for moving the huge cotton crops from Coahoma County. Here, she moves along the flooded Mississippi River past a building with only its roof showing.

This hand-cranked cotton gin is an improved model based on Eli Whitney's invention. Anything must have been better than laboriously picking the fiber from seeds and debris. Using this invention, slaves cleaned only about 50 pounds in a day. Designs and inventions followed that were geared toward higher volume and time-saving processes. (Ken Giorlando.)

This modern and efficient cotton gin with dryers on Hopson Plantation near Clarksdale was operating in 1939. Over 100 years had passed since the hand-cranked invention shown above had been a sensation. At one time, gins were powered by steam, then by electric power. (LC.)

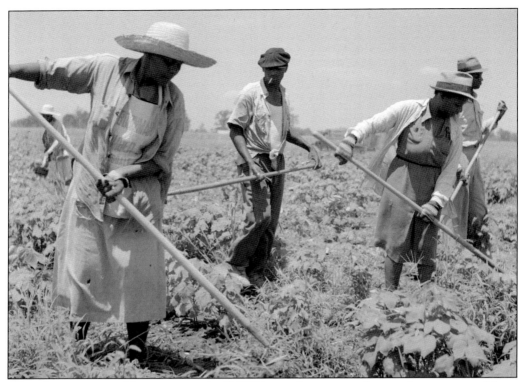

After the invention of the cotton gin by Eli Whitney, the process of separating cotton seed from the fiber was partially solved, and cotton production soared. About the same time, British cotton textile mills were clamoring for American cotton. The expansion of acres planted increased the need for more slaves. This crop was very labor intensive; after Emancipation, throughout the Great Migration, and during World Wars I and II, the labor pool was severely reduced. During the chopping time and cotton-picking seasons, Mexican labor was trucked in, both Italian and German prisoners of war were utilized, Native Americans from the reservation in Philadelphia, Mississippi, were brought in, and representatives were sent to Northern states to recruit workers, using every inducement they could imagine. (Both, LC.)

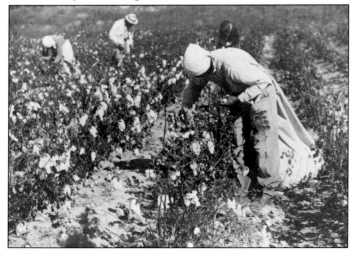

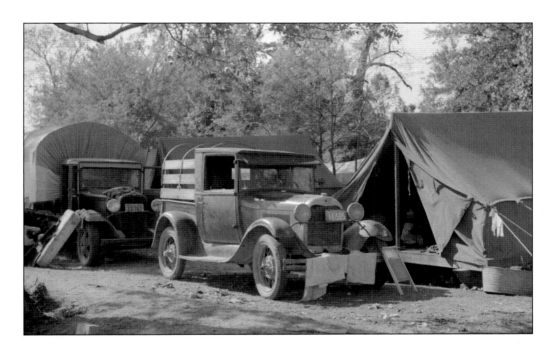

Seasonal Mexican labor lived in camps on Hopson Plantation. They signed with a contractor, who provided transportation to work through the harvesting of the cotton crop. The practice of seasonal labor continued through the years on a smaller scale, and permanent housing replaced the tent camps. (Both, LC.)

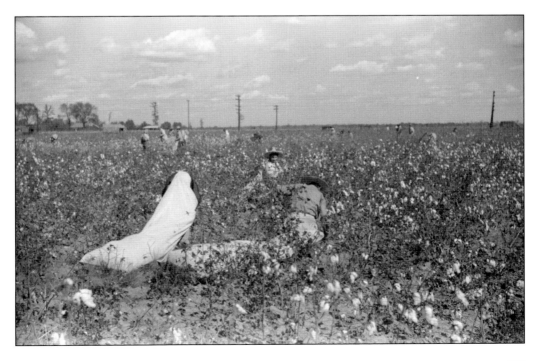

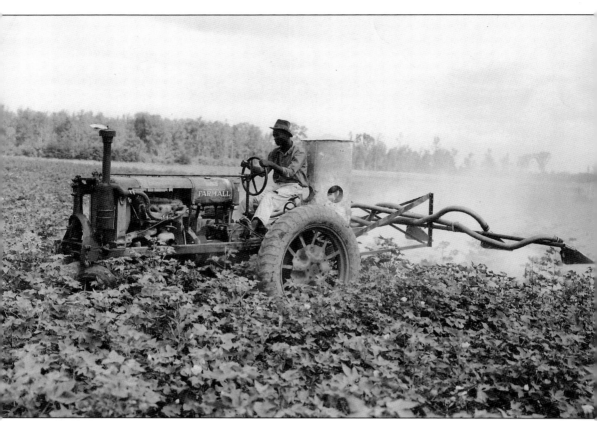

The boll weevil, the insect enemy of cotton, marched up from Mexico in 1892 and presented a major problem, threatening to drive farmers out of the cotton business. In 1920, damage caused by the boll weevil infestation reduced yields by more than 30 percent per acre. The resilient Delta farmers saw that labor was leaving the farms south and west of them because the crops were ruined, and there was no work. Their answer to the boll weevil crisis was to increase their cotton acreage and provide jobs to this labor source and keep them on their farms. From the early 1900s until the late 1940s, the most effective way of dealing with the pests was growing short-season, early-maturing cotton varieties and dusting the crops with calcium arsenate. During World War II, the insecticide dichloro-diphenyl-trichloroethane (DDT) was developed for controlling many insects, including the boll weevil. Even with the crop damage, the cost of chemicals and means to deal with the pest, and the fluctuation of cotton prices, planting so much more acreage helped the farmers survive and continue their fight with this pest.

Increased demand, scarcity of labor, and attractive crop prices brought on by World Wars I and II accelerated the use of labor-saving devices and power machinery on the farm. In 1919, the number of horses and mules on farms reached peak numbers, and from 1920 to 1940 the number of tractors expanded dramatically and dependence on the animals abated. Tractors, like those shown here on Hopson Plantation, made it possible for farmers to work larger areas than before. Plowing and cultivating was not only faster, but this work could be done at the most suitable time. (Both, LC.)

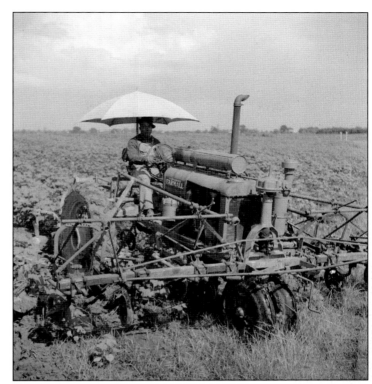

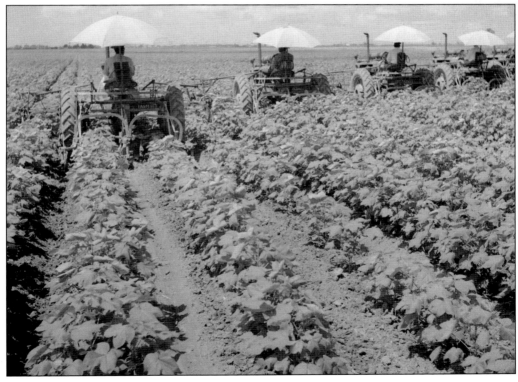

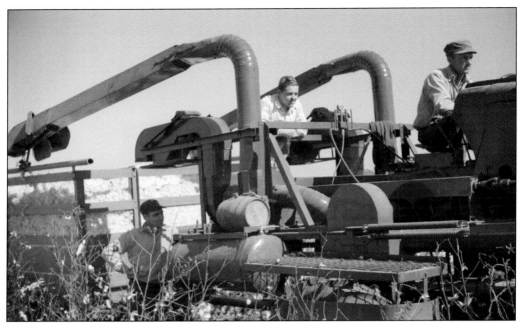

Farmers had long known that only science could solve many problems in their cotton-producing industry. As a result, a Delta branch of the Mississippi Agricultural Experiment Station was authorized by the state legislature in 1909 and was located at Stoneville. Since its inception, the station has played an integral part in the Delta's progress. Testing of cotton pickers by the Rust Cotton Picker Company (above) and International Harvester (below) took place in the 1930s. The early pickers were tractor-driven, and some used vacuum pumps to suck the cotton from the boles. Revolving spindles later proved to be the most efficient means of removing the fiber. In 1944, Hopson Plantation produced the first cotton crop to be mechanically cultivated and harvested. (Both, LC.)

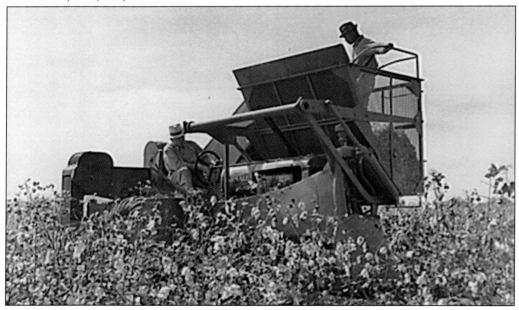

Most gins in the late 1930s had adequate cleaning, extracting, and drying equipment. The last step in the gin was cotton compression, where the clean, dry fiber was pressed into bales three feet by five feet and weighing 500 pounds. Once compressed in the mold, mesh burlap was used to wrap the bale (above). While still under pressure, metal bands were attached to hold the form. Gins that did not have compression equipment transported bales to compresses, such as North Delta Compress & Warehouse Company in Clarksdale. Once compressed, the bales could be held in warehouses for shipment by rail. The smaller size was both cost-effective and easier to handle. With modern gin equipment, the compress was no longer needed, and these facilities became warehouses. Ross Aven (below) served as secretary and general manager of this company. (Above, LC; below, Helen Aven.)

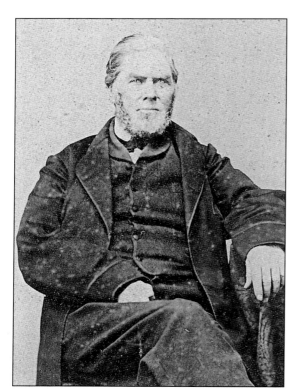

James Irvine, born in 1797, lived and practiced law in Florence, Alabama. He and his family acquired county land totaling 3,529 acres, part of which was known as the Irvine Place/Sheriff Ridge Plantation. The land was advertised for sale in 1875 by William J. Irvine, son of James Irvine, as Irvine Plantation/ Sheriff Ridge Place. When King & Anderson owned the land, the name was changed to Irvin Plantation. (Peter Irvine.)

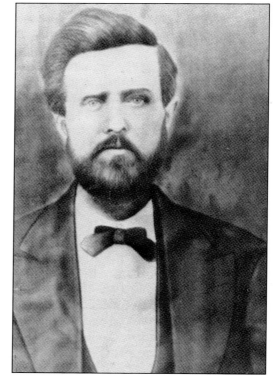

Jackson Sessum Fisher came to Coahoma County in 1858 and managed Irvine Plantation. A friend of the Irvine sons, he went to be with them in Florence, Alabama, when war was declared. He joined Company A, 35th Alabama Regiment, Infantry. Fisher returned to the county in 1866 with his bride, Huldah Elizabeth Robinson, and they lived where the Clarksdale County Club is located today, which was part of Irvine at that time. (Mary Robinson/CPL.)

Five

Blues and Blues History

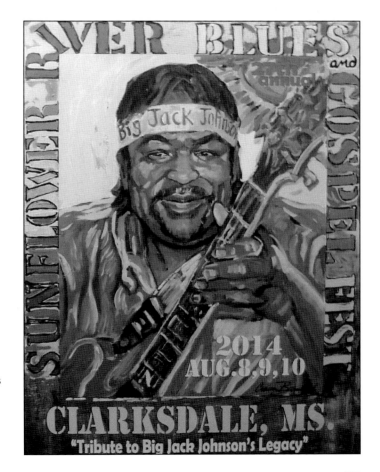

Cotton is a colorful picture of the county, and blues is the powerful sound that penetrates the region. The soulful sounds tell a story from the perspective of the laborers in the field and gospel singers from small churches nearby. There is a rhythm in the older music that reflects the chopping and picking in the fields. The blues express the feelings of the people walking and working those endless rows of cotton. (Sunflower River Blues and Gospel Festival.)

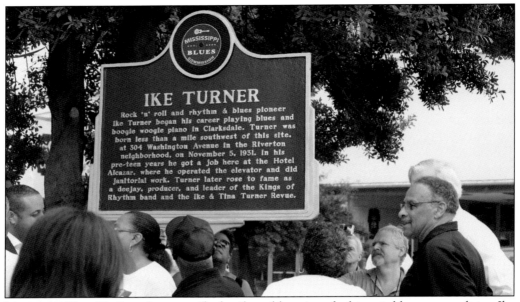

Mississippi Blues Trail markers provide details and locations for historic blues personalities. Ike Turner operated the elevator and did janitorial work at the Alcazar Hotel and was a former deejay on WROX Radio when it was located there. Turner's 1951 record with Jackie Brenston, "Rocket 88," is regarded as one of the first rock 'n' roll songs. Pinetop Perkins was an early influence on Turner's music. (Mississippi Blues Trail.)

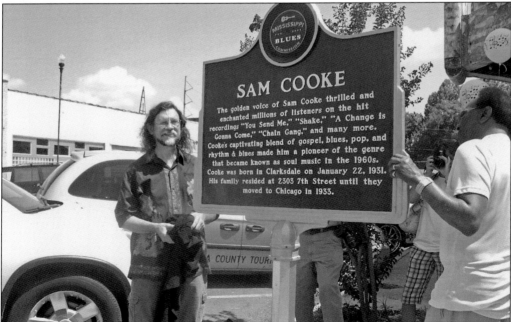

Sam Cooke was born in Clarksdale in 1931, and his family moved to Chicago in 1933. He began as a gospel singer, but when he switched to his own blended style of soul music, he became a success. He wrote and recorded 29 Top 40 soul hits and became known as "Mr. Soul." His hits include "You Send Me," "Chain Gang," and "Twistin' the Night Away." (Mississippi Blues Trail.)

The last move for the Delta Blues Museum was to the historic Clarksdale Freight Depot in 1999. After extensive renovation, the museum expanded to include permanent and traveling exhibits, giving visitors from around the globe the experience of viewing and hearing the history of the blues where the music had its roots. This life-sized wax figure of Muddy Waters sits in his cabin, moved from Stovall Plantation to the museum.

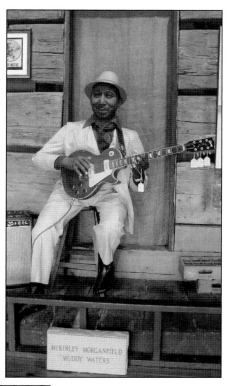

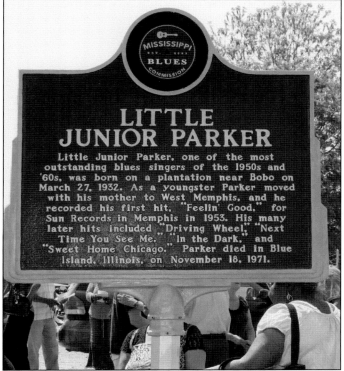

MISSISSIPPI BLUES COMMISSION

LITTLE JUNIOR PARKER

Little Junior Parker, one of the most outstanding blues singers of the 1950s and '60s, was born on a plantation near Bobo on March 27, 1932. As a youngster Parker moved with his mother to West Memphis, and he recorded his first hit, "Feelin' Good," for Sun Records in Memphis in 1953. His many later hits included "Driving Wheel," "Next Time You See Me," "In the Dark," and "Sweet Home Chicago." Parker died in Blue Island, Illinois, on November 18, 1971.

Vocalist and harmonica player Little Junior Parker was born on a plantation near Bobo in 1932. His original band was Little Junior Parker & His Blue Flames. His early recordings did well locally, but they did not catch on outside the area. In late 1953, a recording by Sun Records, "Love My Baby" and "Mystery Train," elevated his status. He enjoyed many more hits. (Mississippi Blues Trail.)

123

James "Super Chikan" Johnson is pictured in his early days as an entertainer. Johnson was a truck driver and a land leveler and then an award-winning songwriter and singer. His nickname came from making his guitar cackle like a chicken. His energetic blues performances are sometimes comical, always original, and are enjoyed around the world, from China to Africa, where he makes friends with his trademark smile and positive outlook.

Located in the Delta Wholesale Grocery & Cotton Company building, dating from the early 1900s, is Ground Zero Blues Club, one of the most recognized names in blues circles around the globe. It stands next to the Delta Blues Museum. Visitors walk in and feel as though they are entering an authentic juke joint with live blues. That is the feeling Bill Luckett, Morgan Freeman, and Howard Stovall set out to replicate.

Shonda Warner has filled a much-needed niche with her general store, located in an old feed store on Delta Avenue. Customers shop for books, jewelry, plants and gardening supplies, gift items, antiques, and a wide range of food products. Shoppers may find themselves at a live blues show or a book signing.

Cat Head Delta Blues & Folk Art, Inc., is a magical place, with an astounding inventory of recordings, books, tourism information, folk art, magazines, and other blues items. Owner Roger Stolle moved here when he experienced the Mississippi blues. In his own words, "I left the warm, comfortable arms of corporate America and chartered a course for a fabled land. Mississippi—my home of the blues."

The crossroads of US 49 and US 61 is where bluesman Robert Johnson supposedly sold his soul to the devil. It is also the site of another story. Abe's Bar-B-Q moved there from Fourth Street, where Abraham Davis founded his business in 1924 under the name Bungalow-Inn. Davis's barbeque reputation spread widely, and tourists passing through or stopping in the city always visit Abe's. Shown here is George Patrick Davis. (Davis family.)

Camp R.O.C.K., a summer camp group, paddles on the Sunflower River in Voyager canoes, handmade by John Ruskey's Quapaw Canoe Company from native trees. The lead teacher is Mark "River" Peoples. Over 10,000 people have been guided on the mighty Mississippi River by this wilderness expedition company. Clients must be willing to paddle and to sleep and eat on sand bars. Testimonials prove how memorable these adventures are for them.

Have a glass of sweet tea and sit on the porch with owners Bill Talbot and Guy Malvezzi awhile, and they will tell you a story of snow-white cotton fields and days spent picking cotton. They may sing a few field chants that tell how life was. The bottle tree wards off evil spirits. Need a place to stay? Not enough room, you say? Well, just look around and you will see accommodations of every shape and size; something will fit. Shack Up Inn, located on historic Hopson Plantation grounds, provides the experience of staying in a renovated shotgun shack, both comfortable and authentic. The plantation also offers renovated bins in the cotton gin. There is even a stage for musicians and a dance floor, along with a restaurant in the main building. Coahoma County's history is waiting to be explored.

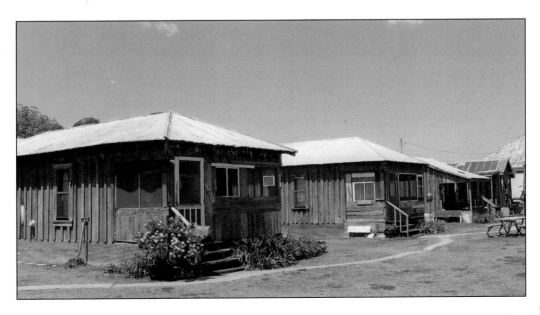

Discover Thousands of Local History Books
Featuring Millions of Vintage Images

Arcadia Publishing, the leading local history publisher in the United States, is committed to making history accessible and meaningful through publishing books that celebrate and preserve the heritage of America's people and places.

Find more books like this at
www.arcadiapublishing.com

Search for your hometown history, your old stomping grounds, and even your favorite sports team.

Consistent with our mission to preserve history on a local level, this book was printed in South Carolina on American-made paper and manufactured entirely in the United States. Products carrying the accredited Forest Stewardship Council (FSC) label are printed on 100 percent FSC-certified paper.